Adobe Photoshop Elements

Adobe Photoshop Elements

A visual introduction to digital imaging

Philip Andrews

Focal Press

OXFORD AUCKLAND BOSTON JOHANNESBURG MELBOURNE NEW DELHI

Focal Press
An imprint of Butterworth-Heinemann
Linacre House, Jordan Hill, Oxford OX2 8DP
225 Wildwood Avenue, Woburn, MA 01801-2041
A division of Reed Educational and Professional Publishing Ltd

℞ A member of the Reed Elsevier plc group

First published 2002

© Philip Andrews 2002

British Library Cataloguing in Publication Data
A catalogue record for this book is available from the British Library

Library of Congress Cataloguing in Publication Data
A catalogue record for this book is available from the Library of Congress

ISBN 0 240 51686 9

For information on all Focal Press publications visit our website at:
www.focalpress.com

Composition by Genesis Typesetting, Laser Quay, Rochester, Kent
Printed and bound in Italy

PLANT A TREE

BTCV
British Trust for
Conservation Volunteers

FOR EVERY TITLE THAT WE PUBLISH, BUTTERWORTH-HEINEMANN
WILL PAY FOR BTCV TO PLANT AND CARE FOR A TREE.

Contents

adobe photoshop elements

adobe photoshop elements

Foreword by Martin Evening

In the mid-eighties a group of professional photographers, including myself, were invited to attend an early demonstration of the Quantel Graphics Paintbox system in action at a digital retouching house in Covent Garden, London. We all sat spellbound as we saw our scanned images instantly transformed by the magic of this new computer system. This was my first glimpse of the future of photography in a digital age. From that day forward I had always wanted to have my own computer retouching system and take control of the magic pen myself. However, I was soon brought back down to earth when I was told how much one of these systems would have cost. Back in those days digital retouching services were the preserve of an elite number of businesses such as advertising agency clients, as these were the only people who could afford to pay the equivalent of a good week's salary for an hour of electronic retouching time.

A few years later, Photoshop made its first appearance – an image editing program that was designed to run on a desktop computer. From these humble beginnings Adobe Photoshop has grown to become the leading image editing computer program used by graphic designers, artists, web designers and photographers from all around the world. Millions of people are now able to scan, capture and retouch their own photographs on desktop computers both at home and at work. It so happens that in the last week alone, I have heard all sorts of people from the bank manager to my hairdresser, describe the amazing things they have been able to do to their pictures using a computer. This is almost as impressive as my mother knowing who PJ Harvey is! And, whenever I present seminars on Photoshop techniques, I am always pleased to note the mixed age range and makeup of the audiences who attend these events. Digital image editing has been truly democratized now that everyone can afford to play. I use the word play deliberately, because even after all the years I have been using Photoshop, I still get a buzz whenever I am sitting at the computer transforming my pictures.

Adobe launched Photoshop Elements quite soon after the release of Adobe Photoshop 6.0. Photoshop Elements is essentially a cut-down version of Photoshop 6.0, yet it contains nearly all the image manipulation power of the parent program, but in an easy-to-use interface. Although Adobe have limited the range of some of the more advanced Photoshop features and functions, they have included a host of cool new features such as the File Browser and Photo Merge commands. Adobe Photoshop Elements is therefore an exciting new program in its own right and it's going to be fun to use as well, but it is also a powerful tool, capable of handling a number of professional tasks. Philip Andrews is a skilled and enthusiastic teacher and here he has produced a very well-written book that will help you, the reader, to quickly get to grips with all aspects of the program. The book is clearly illustrated throughout and you will find that Philip has thoughtfully included a number of practical tips on how to capture better photographs. On top of this, he shows you more than how to operate the program – he also demonstrates how to use Photoshop Elements with examples of practical assignments, such as the production of a school newsletter or an illustrated restaurant menu. In my experience I have found that readers always find it much easier to understand a program when they are provided with project examples that have a logical purpose to them. Philip's book is in every respect refreshingly direct and easy to understand.

Whatever your interest, I am sure that you are going to get a lot of interesting use out of Photoshop Elements. Whether you are into manipulating photographs, wishing to build better websites or produce better looking prints, this book will help you to master all the necessary tools contained in the program. The learning curve has just got shallower!

Martin Evening
www.evening.demon.co.uk
www.photoshopforphotographers.com

Acknowledgements

Always for Kassy-Lee, but with special thanks to Karen, Adrian and Ellena for pretending to be interested in my book-centred obsession that spanned several countries and pervaded the last few months of our lives.

Thanks also to the enthusiastic and very supportive staff at Focal Press whose belief in quality book production has given life to my humble ideas. Cheers to Martin Evening, the 'Guru of GUI', and Rod Wynne-Powell (solphoto@dircon.co.uk), for their technical and 'pixel-based' guidance and to all the image makers who gave so freely of their time and pictures to provide practical examples of 'Real Life Digital Imaging'.

And thanks to Adobe for bringing image enhancement and editing to us all through their innovative and industry leading products, and the other hardware and software manufacturers whose help is an essential part of writing any book of this nature. In particular I wish to thank technical and marketing staff at Adobe, Corel, Nikon, Kodak, Fuji, Canon, and Epson.

Welcome to the World of Digital Imaging

In the last few years the world of imaging has changed forever. Sophisticated digital jobs that were once the closely guarded domain of industry professionals are now being handled daily by home and business users.

This book introduces you to the techniques of the professionals and, more importantly, shows you how to use these skills to produce high quality images for yourself and your business. Centered around Adobe's new imaging software, Photoshop Elements, you will learn the basics of good

Figure 1.1 Digital imaging skills can be used to manipulate and enhance images so that they can be used in a variety of personal and business publications and products

digital production from the point of capturing the picture, through simple manipulation techniques to outputting your images for print and web.

To help reinforce your understanding you can practise with the same images that I have used in the step-by-step demonstrations by downloading them from the book's website (www.guide2elements.com). Also you will find real life examples scattered throughout the text of how you can use your new found skills to enhance your own images, or create professional graphics for your business publications. See Figure 1.1.

The beginning – the digital image

Computers are amazing machines. Their strength is in being able to perform millions of mathematical calculations per second. To apply this ability to working with images we must start with a description of pictures

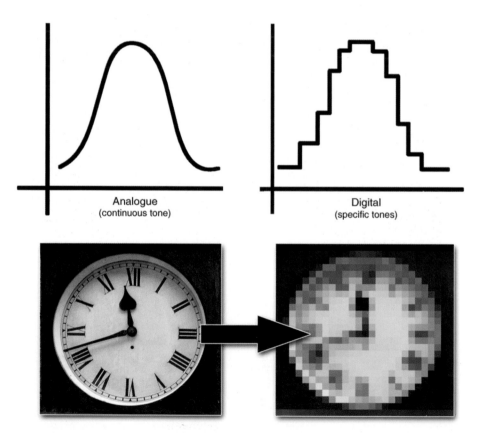

Figure 1.2 Continuous tone images have to be converted to digital form before they can be manipulated by computers

that the computer can understand. This means that the images must be in a digital form. This is quite different from the way our eye, or any film-based camera, sees the world.

With these devices we record pictures as a series of 'continuous tones' that blend seamlessly with each other. To make a version of the image the computer can use, the tones need to be converted to a digital form. The process involves sampling the image at regular intervals and assigning a specific color and brightness to each sample. In this way, a grid of colors and tones is created that, when viewed from a distance, will appear like the original image or scene. Each individual grid section is called a picture element, or pixel. See Figures 1.2 and 1.3.

Figure 1.3 A digital picture is made up of a grid of picture elements or pixels

Making the digital image

Digital files can be made by taking pictures with a digital camera or by using a scanner to convert existing prints or negatives into pixel form.

Digital cameras have a grid of sensors, called CCDs (Charge Coupled Device), in the place where traditional cameras would have film. Each sensor measures the brightness and color of the light that hits it. When the values from all sensors are collected and collated, a digital picture results. See Figure 1.4.

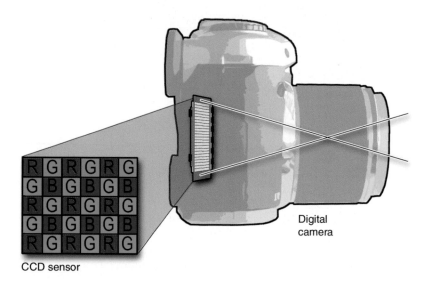

Digital camera

CCD sensor

Figure 1.4 The CCD sensor takes the place of film in digital cameras

Scanners work in a similar way except that these devices use rows of CCD sensors that move slowly over the original sampling the picture as they go. See Figure 1.5. Generally different scanners are needed for converting film and print originals; however, some companies are now making products that can be used for both.

Quality factors in a digital image

The quality of the digital file is determined by two factors – the number of pixels that governs the amount of detail and the number of colors that defines the range (or gamut) reproduced in the image.

The number of pixels in a picture is represented in two ways – the dimensions, 'the image is 900 × 1200 pixels', or the total pixels contained

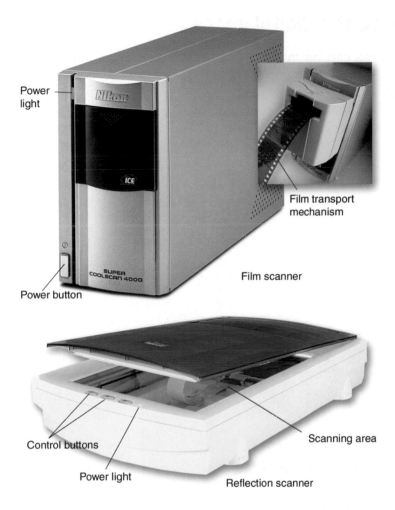

Power light

Film transport mechanism

ICE

Power button

SUPER COOLSCAN 4000

Film scanner

Control buttons

Scanning area

Power light

Reflection scanner

Figure 1.5 Photographs and negatives, or slides, are converted to digital pictures using either film or flatbed scanners

in the image, 'it is a 3.4 mega-pixel picture'. Generally, a file with a large number of pixels will produce a better quality image overall and provide the basis for making larger prints than a picture that contains fewer pixels. See Figure 1.6.

The second quality consideration is the total number of colors that can be recorded in the file. This value is usually referred to as the 'color bit depth' of the image. The current standard is 24-bit color. A picture with this depth is made up of a selection of a possible 16.7 million colors. In practice this is the minimum number of colors needed for an image to appear photographic.

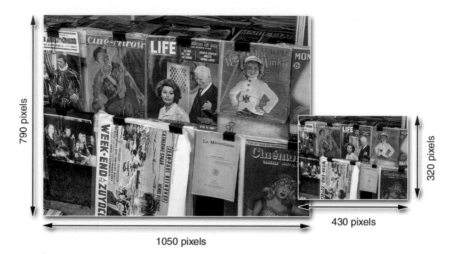

790 pixels

320 pixels

1050 pixels

430 pixels

Figure 1.6 The size of a digital image is measured in pixels. Images with large pixel dimensions are capable of producing big prints and are generally better quality

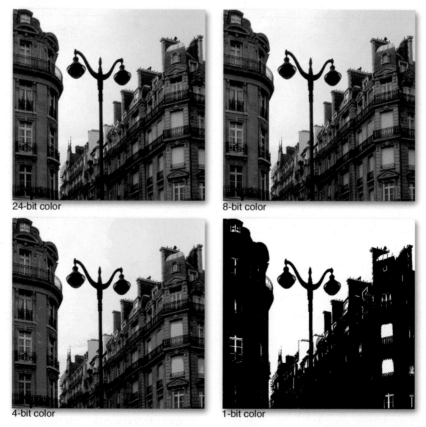

24-bit color

8-bit color

4-bit color

1-bit color

Figure 1.7 Color or bit depth determines the number of colors possible in a digital file

In the early years of digital imaging 256 colors (8 bit) was considered the standard. Though good for the time, the color quality of this type of image is generally unacceptable nowadays. In fact, new camera and scanner models are now capable of 36- or even 48-bit color. The larger bit depth helps to ensure greater color and tonal accuracy. See Figure 1.7.

The steps in the digital process (see Figure 1.8)

The digital imaging process contains three separate steps – *capture*, *manipulate* and *output*.

Capturing the image in a digital form is the first step. It is at this point that the color, quality and detail of your image will be determined. Careful manipulation of either the camera or scanner settings will help ensure that your images contain as much of the original's information as possible. In particular you should ensure that delicate highlight and shadow details are evident in the final image.

If you notice that some 'clipping', or loss of detail, is occurring in your scans try reducing the contrast settings. If your camera pictures are too dark, or light, adjust the exposure manually to compensate. It is easier to capture the information at this point in the process than try to recreate it later.

Manipulation is where the true power of the digital process becomes evident. It is here that you can enhance and change your images in ways that are far easier than ever before. Altering the color,

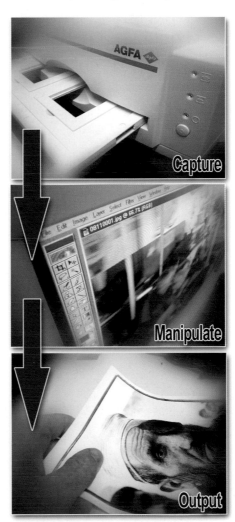

Figure 1.8 The digital imaging process contains three steps – capture, manipulate *and* output

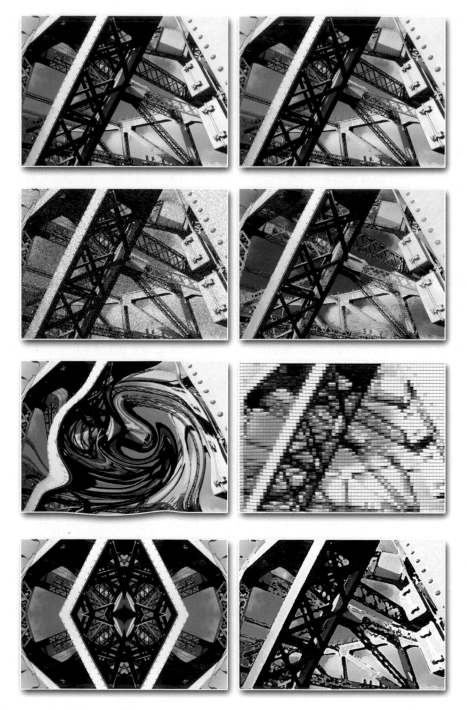

Figure 1.9 An image-editing program can enhance, manipulate and change a base file in many different ways

contrast or brightness of an image is as simple as a couple of button clicks. Changing the size or shape of a picture can be completed in a few seconds and complex manipulations like combining two or more images together can be completed in minutes, not the hours, or even days, needed with traditional techniques. See Figure 1.9.

This one step gives digital illustrators the power to take a base image and alter it many times so that it can be used in a variety of situations and settings. Once altered it is possible to output this same image in many ways. It can be printed, be used as an illustration in a business report, become part of a website, be sent to friends on the other side of the world as an email attachment, or projected onto a large screen as a segment in a professional presentation.

Where does Photoshop Elements fit into the process? (see Figure 1.10)

Photoshop Elements is an image enhancement and manipulation program. Put simply, this means that it is the pivot point for the whole

Figure 1.10 Photoshop Elements is built on the same editing engine as its professional cousin, Photoshop 6

digital imaging process. Its main job is to provide the tools, filters and functions that you need to change and alter your pictures. Elements is well suited for this role as it is built upon the same core structure as Adobe's famous professional-level program, Photoshop 6. Many of the functions found in this industry-leading package are also present in

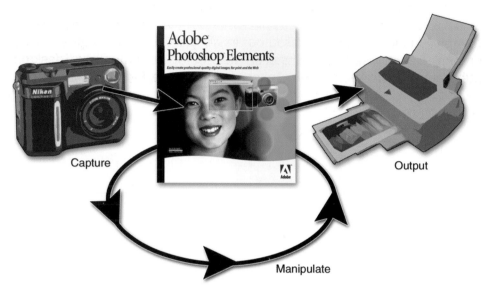

Figure 1.11 Elements is the center of the imaging process providing the ability to import, manipulate and output digital pictures

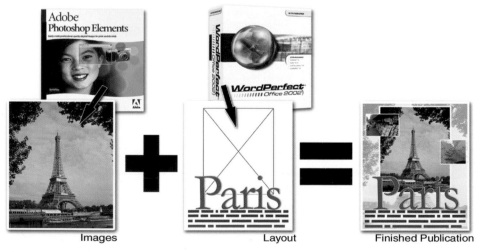

Figure 1.12 By coupling Elements with other software you can produce a variety of professional publications for yourself or your business

Elements, but unlike Photoshop, Adobe has made Elements easier to learn and, more importantly, easier to use than its professional cousin. In this way, Adobe has thankfully taken into account that although a lot of users need to produce professional images as part of their daily jobs, not all of these users are, or want to be, imaging professionals. See Figure 1.11.

In addition, Elements contains features designed to download digital pictures from your camera, or scanner, directly into the program, as well as functions that allow you to output easily your finished images to web or print. When used in conjunction with other programs, like desktop publishing packages, it is also possible to include Element's enhanced images in professionally prepared brochures, advertisements and reports. See Figure 1.12.

Introducing Photoshop Elements

Photoshop Elements is the type of software tool that photographers, designers and illustrators use daily to enhance and change their digital images. There are many companies who make programs designed for this purpose. The products they produce all contain a common set of tools along with some special features particular to each manufacturer. Adobe has a substantial advantage over most of its competitors because it also produces the flagship for the industry – Photoshop. Now in its sixth version, this product, more than any other, has forged the direction for image editing and enhancement software worldwide. In fact the tools, functions and interface that are now standard to graphics packages everywhere owe a lot to earlier versions of Photoshop.

With the release of Elements, Adobe has recognized that not all digital imaging consumers are the same. Professionals do require a vast array of tools and functions to facilitate almost any type of image manipulation, but there are a significant and growing number of users that want the robustness of Photoshop but don't require all the 'bells and whistles'. This makes Elements sound like a cut-down version of Photoshop and, to some extent, it is, but there is a lot more to this package than a mere subset of Photoshop's features. Adobe has taken the time to listen to its customers and has designed and included in Elements a host of extra tools and features that are not available in Photoshop. It's this combination of proven strength and new functions that makes Elements the perfect imaging tool for digital camera and scanner owners who need to produce professional level graphics economically. See Figure 2.1.

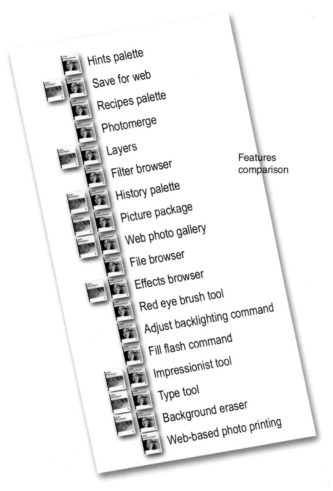

Hints palette
Save for web
Recipes palette
Photomerge
Layers
Filter browser
History palette
Picture package
Web photo gallery
File browser
Effects browser
Red eye brush tool
Adjust backlighting command
Fill flash command
Impressionist tool
Type tool
Background eraser
Web-based photo printing

Features comparison

Figure 2.1 Elements combines the best RGB features of Photoshop with a host of useful functions and tools that are all its own

The interface

The program interface is the link between the user and the software. Most graphics packages work with a system that includes a series of menus, tools, palettes and dialog boxes. These devices give the user access to the features of the program. The images themselves are contained in windows that can be sized and zoomed. Elements is available for both the Macintosh and Windows platforms. The interface for each system is very similar with the only differences being the result of the underlying operating system of each computer. See Figures 2.2 and 2.3.

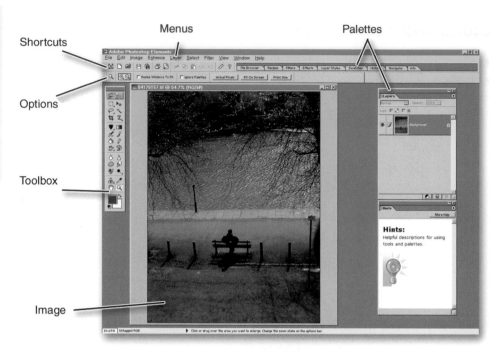

Figure 2.2 The Windows interface for Adobe Photoshop Elements

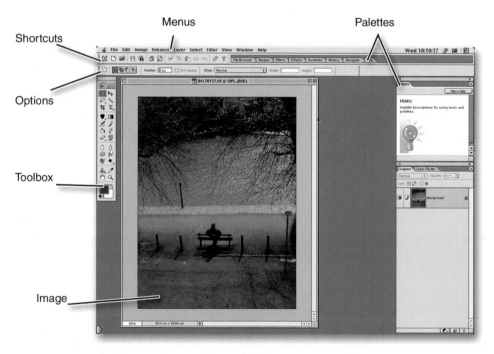

Figure 2.3 The Macintosh interface for Adobe Photoshop Elements

Menu bar (see Figure 2.4)

Most programs contain a menu bar with a range of choices for program activities. In addition to the standard File, Edit, View, Window and Help menus, Elements contains five other specialist headings designed specifically for working with digital pictures.

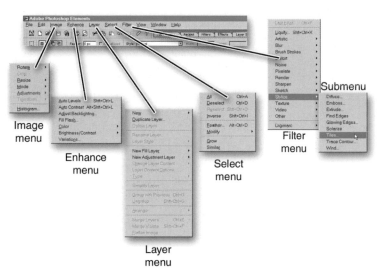

Figure 2.4 Elements contains five specialist menus as well as the usual File, Edit, View, Window and Help headings

The Image menu contains features that change the shape size, mode and orientation of the picture. Grouped under the Enhance heading are a range of options for altering the color, contrast and brightness of images. All functions concerning image layers and selections are contained under the Layer and Selection menus. The special effects that can be applied to images and layers are listed under the Filter menu.

Selecting a menu item is as simple as moving your mouse over the menu, clicking to show the list of items and then moving the mouse pointer over the heading you wish to use. With some selections a second menu (submenu) appears from which you can make further selections.

Toolbox (see Figure 2.5)

Unlike menu items, tools interact directly with the image and require the user to manipulate the mouse to define the area or extent of the tool's

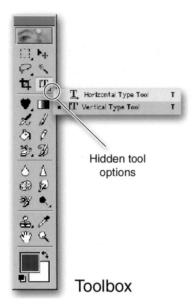

Hidden tool options

Toolbox

Figure 2.5 The toolbox contains a set of tools that are used directly in the image window

effect. Over the years the number and types of tools have been distilled to a common few that find their way into the toolbox of most imaging programs. These include the Magnifying Glass, the Brush, the Magic Wand, the Lasso and the Cropping tool.

In addition to these each company produces a specialist set of customized tools that are designed to make particular jobs easier. Of these Elements users will find the Red Eye Brush, Custom Shape and Impressionist Brush tools particularly useful. Some tools contain extra or hidden options which can be viewed by clicking and holding the mouse key over the small triangle in the bottom right-hand corner of the tool button.

Tool types

The many tools can be broken into different groups based on their function.

Selection tools

Selection tools are designed to highlight parts of an image. This can be achieved by drawing around a section of the picture using either the Marquee or Lasso tools or by using the Magic Wand tool to define an area by its color. Careful selection is one of the key skills of the digital imaging worker. Often the difference between good quality enhancement and a job that is coarse and obvious is based on the skill taken at the selection stage. See Figure 2.6.

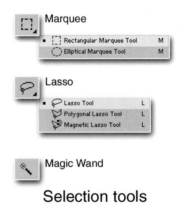

Selection tools

Figure 2.6 Selection tools are used to isolate a specific area of a picture

Painting/Drawing tools

Although a lot of photographers and designers will employ Elements to enhance images captured using a digital camera or scanner, some users make pictures from scratch using the program's drawing tools. Illustrators in particular generate their images with the aid of tools such as the Paint Bucket, Airbrush and Pencil. This is not to say that it is not possible to use drawing or painting tools on digital photographs. In fact, the judicious use of tools like the Brush can enhance detail and provide a sense of drama to your images. See Figure 2.7.

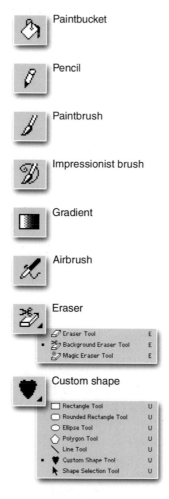

Paintbucket

Pencil

Paintbrush

Impressionist brush

Gradient

Airbrush

Eraser

Eraser Tool	E
Background Eraser Tool	E
Magic Eraser Tool	E

Custom shape

Rectangle Tool	U
Rounded Rectangle Tool	U
Ellipse Tool	U
Polygon Tool	U
Line Tool	U
Custom Shape Tool	U
Shape Selection Tool	U

Painting tools

Figure 2.7 Painting and drawing tools are used to add details to existing images or even create whole pictures from scratch

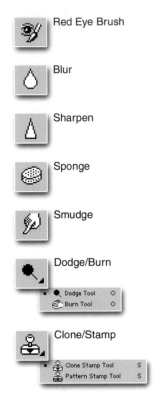

Enhancement tools

Figure 2.8 Enhancement tools are used to alter existing images to improve their overall appearance

Enhancement tools

These tools are designed specifically for use on existing pictures. Areas of the image can be sharpened or blurred, darkened or lightened and smudged using features like the Burning or Dodging tool. The Red Eye Brush is great for removing the 'devil' like eyes from flash photographs and the Clone Stamp tool is essential for removing dust marks as well as any other unwanted picture details. See Figure 2.8.

Movement tools

The Hand and Move tools help users navigate their way around images. This is especially helpful when the image has been 'zoomed' beyond the confines of the screen. When a picture is enlarged to this extent it is not possible to view the whole image at one time, using the Hand tool the user can drag the photograph around within the window frame. See Figure 2.9.

Text tools

Combining text with images is an activity that is used a lot in business applications. Elements provides the option to apply text horizontally across the page, or vertically down the page. See Figure 2.10.

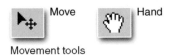

Movement tools

Figure 2.9 The Hand tool is used to navigate around enlarged pictures, whereas the Move tool alters the position of image parts relative to the canvas

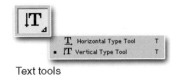

Text tools

Figure 2.10 The Text tool is used to add type to images

Options bar (see Figure 2.11)

Each tool and its use can be customized by changing the values in the options bar, located below the shortcuts bar at the top of the screen. The default settings are displayed automatically when you select the tool. Changing these values will alter the way that the tool interacts with your image.

Palettes (see Figure 2.11)

Palettes are small windows that help the user enhance their pictures by providing extra information about images or by listing a variety of modification options. Palettes can be docked in the Palette Well or

Options bars

Palettes

Figure 2.11 The way that a selected tool behaves is based on the values found in the options bar. Palettes provide a visual summary of image enhancement tools and features

dragged and dropped onto the main editing area. Commonly used functions can be grouped by dragging each palette by their tab onto a single palette window.

Shortcuts bar (see Figure 2.12)

Shortcuts bar Palette well

Figure 2.12 Shortcuts are button versions of commonly used menu items. The Palette Well is used to store palettes when not in use, but they remain within view

The shortcuts bar contains button versions of commonly used commands. The same commands can also be accessed via the menu bar. To the right of this section of the bar is the Palette Well. Here the palettes can be minimized and stored away from the main editing space providing more screen area for image windows.

3 First Steps

As a simple introduction to the program, this chapter will take you through the first basic steps involved in capturing, cropping, saving and printing an image.

When Elements is first opened the user is presented with a Quick Start screen containing several options for creating an image. See Figure 3.1.

Figure 3.1 The Element's Quick Start screen appears as the user opens the program. It can also be displayed by selecting Window>Show Quick Start from the menus

Quick Start>New

The 'New' option creates an Elements picture from the settings selected in the New dialog box. The box has sections for the image's name, width, height, resolution and mode. The content of the image can be chosen from the list at the bottom of the box. See Figure 3.2.

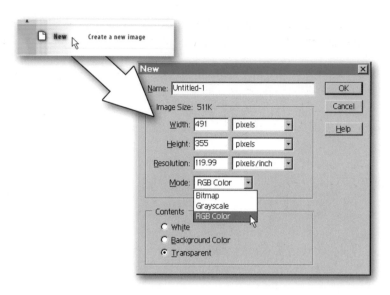

Figure 3.2 The New dialog box is used for setting the dimensions, resolution and mode of new images

At this stage it is important to remember that the quality of the image, and the size that it can be printed, is determined in part by its pixel dimensions. It's good practice to choose the pixel dimensions for your image based on what that picture will be used for. An image that is destined to become a poster will need to have substantially more pixels than one needed for a postage stamp.

'Just how many more pixels are needed?' is a good question. The answer can be found in the numbers you put into the New dialog. The final dimensions of your product should be input directly into the 'Width' and 'Height' boxes. Next the print resolution that you will use when outputting your image is placed in the 'Resolution' box. Elements does the rest

Image Resolution	Proposed Use
72 dpi	Screen or web use only
150 dpi	Draft quality inkjet prints
200 – 300 dpi	Photographic quality using good inkjet printer
300 dpi	Standard minimum resolution for offset printing

Figure 3.3 Different end products require different resolutions. Use this guide to help you determine the correct resolution needed for a particular image

working out the exact file size needed to suit your requirements. If you are unsure what print resolution to input, use the guide as a starting point. See Figure 3.3.

If your picture is to be printed at a variety of sizes, create your image for the largest size first and then downsize the image when necessary. Making large images smaller preserves much of the quality of the original file in the smaller version, but the reverse is not true. Enlarging small files to suit a big print job will always produce a poorer quality file, especially when it is compared to one that was created at the right size in the first place. See Figure 3.4.

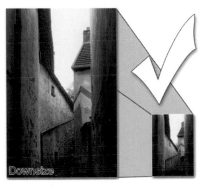 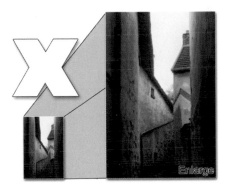

Figure 3.4 Downsizing images is acceptable but enlarging always produces a final picture that is poorer in quality. Only enlarge a small picture as a last resort

Quick Start>Open

The 'Open' option in the Quick Start screen is used for opening existing images. These could be ones that you created at another time and saved to disk, from a CD-ROM, or pictures sent to you by a friend as email attachments. Elements can open and save a wide range of files and file types. Clicking the Open button will take you directly to a file dialog where you can select the drive and folder/directory where your image is saved. See Figure 3.5.

Quick Start>Paste

A lot of current programs contain the options to copy (Edit>Copy) and paste (Edit>Paste) information. For the most part these functions occur within a single piece of software, but occasionally it is necessary to copy

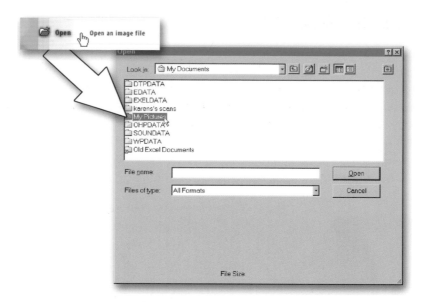

Figure 3.5 The Open dialog allows you to open existing images from the directories/folders on your computer

an image, or some text, from one program and place it in another. Using the 'Paste' command, Elements allows for information that has been stored in memory as part of the copying process to be pasted as a new file. See Figure 3.6.

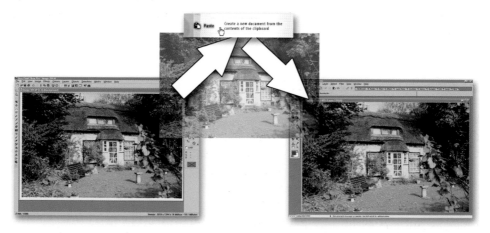

Figure 3.6 Information copied in another program can be pasted into Elements as a new image using the Paste option from the Quick Start screen

Quick Start>Acquire

The 'Acquire' button enables users to obtain images directly from their scanners or digital cameras. A dialog asking the user to 'Select an input source' appears after clicking on Acquire. The number and type of sources that you have listed here will depend on what pieces of hardware you have installed on your computer. See Figure 3.7.

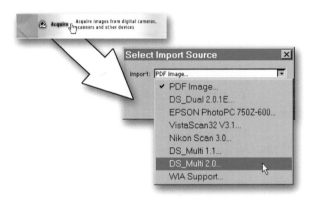

Figure 3.7 The Acquire option allows images from scanners and cameras to be downloaded directly into Elements

Generally as part of this hardware installation process a small piece of software is loaded onto your machine. Called a TWAIN driver this program allows a range of applications to control the scanner or camera. Elements uses this driver to download images direct from your scanner or camera.

Ensuring good scans

When you scan an image using a print or film scanner you are creating a digital file. Unlike the situation with most digital cameras where the pixel dimensions of the file are fixed, images made via a scanner can vary in size depending on the settings used to create them. To make sure that you have enough pixels for your requirements the same rules we used for creating a new image apply here. At the time of scanning you should know the size that your final product will be. Use this information to set the controls on the scanner so that you end up with a file big enough to suit your needs.

As a rough guide remember that if your original print or film frame is small you will need to scan at a high resolution in order to produce a reasonable file size. Large print originals on the other hand can be scanned at lower resolutions to achieve the same file size. Sound a little confusing? It can be, but most scanner software is designed to help you through the maze. See Figure 3.8.

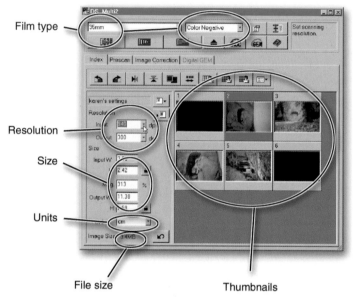

Figure 3.8 Scanner software contains settings to vary the output size and resolution of your images

After launching the driver perform a Preview scan. This will produce a quick low-resolution picture of the print or negative. Using this image as a guide select the area to be scanned with the Marquee or Cropping tool. Next adjust the brightness, contrast and color of the image to ensure that you are capturing the greatest amount of detail as possible. Now input your scan sizes concentrating on ensuring that the output dimensions and resolution are equal to your needs. See Figure 3.9.

Downloading images from cameras

With the camera connected to the computer, select its driver from the list in the Acquire section of the Quick Start screen. At this point most drivers will provide a group of thumbnails that represent the images currently

adobe photoshop elements

Preview

Selected
area

Change
image

alter
sizes

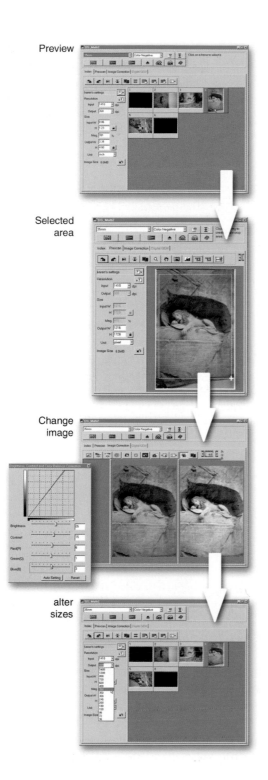

*Figure 3.9 Making a scan is a
four-step process that starts with
previewing the image. Next the
area to be scanned is selected,
the brightness, contrast and
color changed (if needed) and
finally the output dimensions
and resolution set*

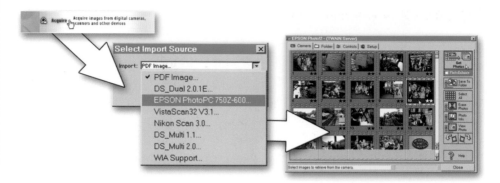

Figure 3.10 Camera drivers produce a set of thumbnails from which you select the images to be downloaded

saved on your camera. Selecting a thumbnail will then give you the option of downloading the picture directly into Elements. As the photograph is already captured few image controls are available as part of the driver software. Decisions about resolution, exposure, contrast and color are made at the time of shooting and the role of the TWAIN software is merely to import the picture into different programs. See Figure 3.10.

Figure 3.11 Images are rotated by using the options found under the Image>Rotate menu

Rotating (see Figure 3.11)

Once you have sourced your image it will be displayed in Elements in its own window. If the orientation of the photograph is incorrect you can rotate the whole picture using the Image>Rotate>Canvas Left or Right options. Rotating the canvas 180° will turn the picture upside down. Flipping the canvas provides a mirror image of the original. The other options in this menu are for rotating separate layers in an image. For more information on layers see Chapter 6.

Cropping

Cropping a picture can help add drama to an image by eliminating unneeded or unwanted detail. It can also be a good method for altering the orientation of a crooked scan. You can crop your images in two ways using Elements.

1 First, select the Marquee tool. Click and drag the tool over the image to define a selection. Then choose Image>Crop from the menu bar. See Figure 3.12.
2 If you want a little more control then try using the specialist Crop tool. Looking like a set of easel arms, it sits just below the Lasso in the toolbox. Once selected, click and drag on the image surface. You will see a marquee like box appear. The box can be resized at any time by dragging the handles positioned at the corners or sides. When you are

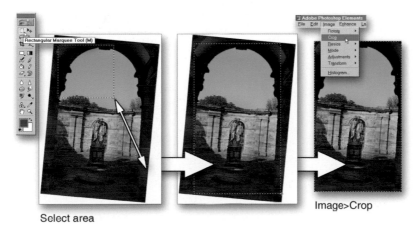

Select area

Image>Crop

Figure 3.12 The Marquee tool is used to select an area that is then cropped using the menu option Image>Crop

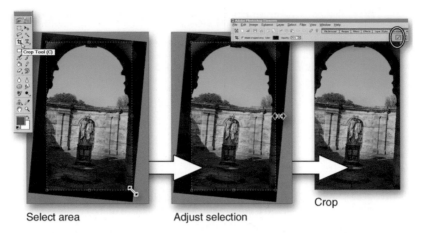

Select area Adjust selection Crop

Figure 3.13 The Crop tool allows adjustment of the selection via the handles positioned at the corners and sides of the bounding box

satisfied with the changes, crop the image by either clicking the OK button in the options bar or double clicking inside the crop marquee. See Figure 3.13.

Straightening

The crop marquee can also be rotated to suit an image that is slightly askew. You can rotate the box by clicking and dragging the mouse pointer outside the edges. Now when you click the OK button the image will be cropped and straightened. See Figure 3.14.

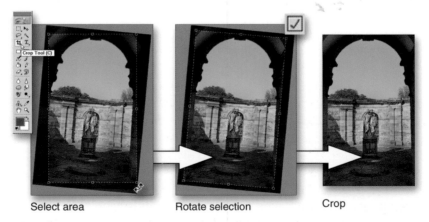

Select area Rotate selection Crop

Figure 3.14 Rotating the Crop tool's selection provides the option for straightening crooked images

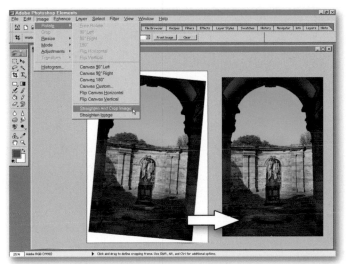

Automatic straighten and crop

Figure 3.15 Elements also provides automated straightening and cropping options

If this all seems a little too complex, Elements also supplies automatic 'straighten' and 'crop and straighten' functions. Designed especially for people like me who always seem to get their print scans slightly crooked, these features can be found at the bottom of the Image>Rotate menu. See Figure 3.15.

Undo, Revert and History

With so many options available for changing images it's almost inevitable that occasionally you will want to reverse a change that you have made. Elements provides several methods to achieve this. The Undo control, Edit>Undo, will successfully take your image back to the way it was before the last change. If you are unhappy with all the alterations you have made since opening the file you can use the Revert feature, File>Revert, to exchange the saved version of your file with the one currently on screen. See Figure 3.16.

The History palette provides complete control over the alterations made to your image. Each action is recorded as a separate step in the palette. Reversing any change is a simple matter of selecting the previous step in the list. These steps can also be accessed through the Edit>Step Backward or Step Forward menu options. See Figure 3.17.

Figure 3.16 Image changes can be reversed by using either the Undo feature (Edit>Undo) or Revert to Saved option (File>Revert)

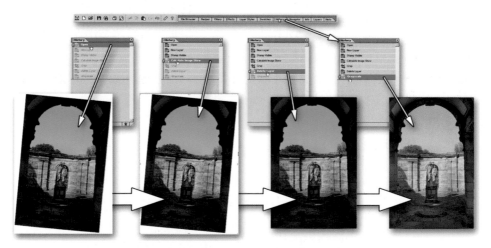

Figure 3.17 The History palette provides the facility to step backwards through the most recent image changes

Zooming in and out

Images can be viewed at different magnifications within Elements. To alter the size of the picture on screen, use either the menu option View>Zoom In or Zoom Out, or the Zoom tool. Clicking on a picture with the tool

selected will enlarge the picture and clicking with the Alt key (Windows) or Option key (Mac) held down will reduce the size. Clicking and dragging will draw a marquee, which will then enlarge to fill your window. See Figure 3.18.

Navigating

When the picture is enlarged beyond the boundaries of the window you will only be able to see a small section of the image at one time. To navigate around the picture use the Hand tool to click and drag the picture

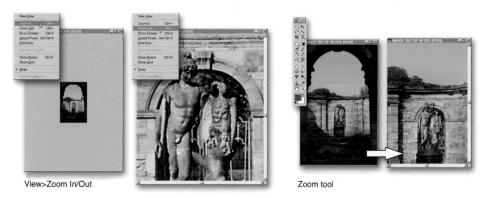

View>Zoom In/Out Zoom tool

Figure 3.18 Images can be enlarged or reduced on screen by using either the Zoom In or Out feature (View>Zoom In or Out) or the Zoom tool

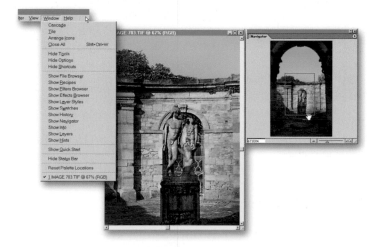

Figure 3.19 The Navigator palette provides both zoom and movement control in one feature. If you have a large screen this is a good palette to have visible all the time

within the box. Alternatively, Elements contains a special Navigator window where you can interactively enlarge and reduce image size as well as move anywhere around the image boundaries. See Figure 3.19.

Printing

The falling price of quality inkjet printers means that more and more people are now able to output photographic quality prints right at their desktop. To help make the process easier Elements contains a Print Preview command, File>Print Preview. The dialog shows how the image will be printed on the paper size selected. It also provides the ability to change printer settings, page orientation and to interactively increase or decrease the size the picture prints. See Figure 3.20.

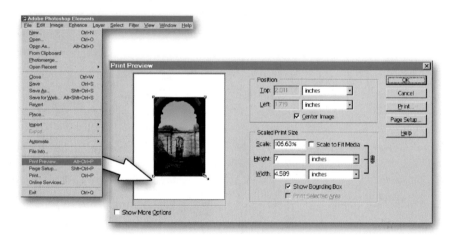

Figure 3.20 The Print Preview option (File>Print Preview) allows users to interactively control the size and position of images on the printed page

Saving

Whilst you are making changes to your image, the picture is stored in the memory (RAM) of the computer. With the alterations complete the file should then be saved to a hard drive or disk. This is a three-step process that starts by choosing File>Save from the menu bar. With the dialog open, navigate through your hard drive to find the directory/folder you wish to save your images in. Next, type in the name for the file and select the file format you wish to use. See Figure 3.21.

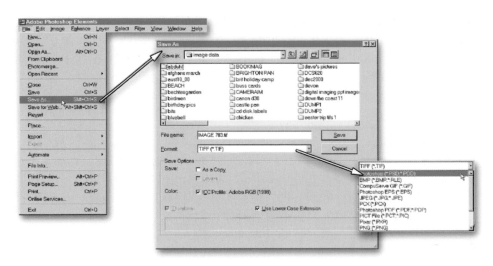

Figure 3.21 Saving images is an important part of the imaging process as it is this step that commits all changes permanently to memory

For most images you should use the Photoshop or PSD format. This option gives you a file that maintains all of the specialized features available in Elements. This means that when you next open your image you will be able to continue to use items like layers and editable text. If on the other hand you want to share your images with others, either via the web or over a network, then you can choose to save your files in other formats like JPEG or TIFF. Each of these options provides more compact files than PSD but doesn't support Elements' advanced features. See Figure 3.22.

File Type	Compression	Color Modes	Layers	Additional Text	Uses
Photoshop (.psd)	✘	RGB, CMYK, Grayscale, Indexed Color	✔	✔	DTP, Internet, Publishing, Photographic
GIF (.gif)	✔	Indexed Color	✘	✘	Internet
JPEG (.jpg)	✔	RGB, CMYK, Grayscale	✘	✔	DTP, Internet, Photographic
TIFF (.tif)	✔	RGB, CMYK, Grayscale, Indexed Color	✘	✔	DTP, Publishing, Photographic
PNG (.png)	✔	RGB, Grayscale, Indexed Color	✘	✘	Internet

Figure 3.22 For most users the Photoshop or PSD format should be used. Other file types have characteristics, like compression, that make them a better choice when sharing files, especially across the Internet

Real life digital imaging: the school newsletter

Part of the job of running a busy school is maintaining the communications between staff, students and parents. In recent years a lot of schools have found that producing a regular newsletter helps to keep everyone informed. With the advent of lower priced cameras and scanners the humble single page text document has grown into a publication that is full of photographs of students, staff and the school activities.

Wade Haynes, the principal of Wynum North State High School, regularly uses digital images in his school's newsletter. 'It provides the school community with the opportunity to review the week's activities. The students love looking for themselves and their friends in print. Parents also appreciate the extra insight it gives them into school life.'

The staff and students at the school source their digital images either directly from digital cameras or from prints that have been scanned. Next they are imported directly into an image editing program where they are cropped, straightened and resized. It is also at this point that the brightness and contrast of the images are improved. From here the pictures are placed into a word processing package containing a template of the magazine. The finished product is then printed out using a high quality inkjet printer before being copied and distributed to school families.

Web link: You can try your hand at creating great newsletters by downloading the template files found on the book's website.

Captions to Figure 3.23 (see page 37)

1 Students and staff shoot images using a digital camera at school activities during the week
2 Back in the office or classroom the camera is connected to a computer
3 The images are viewed as thumbnails and then downloaded from the camera into image editing software
4 The best photographs are sized, rotated, their contrast and brightness adjusted and then saved to disk
5 On occasions where the digital cameras are not available traditional film cameras are substituted. The prints from the camera are then converted to digital data using a flatbed scanner
6 The images from the scanner are then sized, rotated, their contrast and brightness adjusted and saved to disk
7 With the pictures now complete, the template for the school's newsletter is opened in a word processing package. The images are imported into the software and positioned in the layout of the page
8 A high quality master print of the completed newsletter is made on an inkjet printer or laser printer
9 The school office staff then use a photocopier to duplicate the newsletter ready for distribution

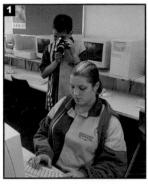

Shoot school activities

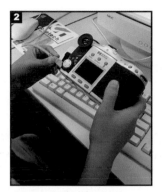

Connect camera to a computer

Select images from thumbnail previews

Adjust selected images

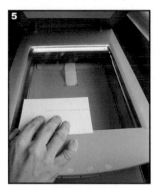

Scan prints

Adjust scanned images

Import images into layout program

Print a master copy

Duplicate newsletter

Figure 3.23 (Full captions provided on page 36)

4 Simple Image Changes

Now that you know how to import, crop, print and save images you can try your hand at some simple changes. It is here that you will start to see the power of the digital process. With a few clicks of the mouse you can perform simple picture adjustments and enhancements easier than ever before. This chapter will take you step by step through these changes and also show you how these techniques are being used in real life to produce stunning photographs and effective business graphics.

Popularity can be a problem

One of the truly amazing features of digital imaging is the diversity of people using the technology. Many individuals in various occupations in different countries across the world use computer-based picture making as part of their daily work or personal life. The popularity of the system is both its strength and, potentially, one of its weaknesses.

On the positive side it means that an image I make in Australia can be viewed in the United Kingdom, enhanced in the United States and printed in Japan. Each activity would involve importing my picture into a different computer running an image-editing package like Elements. This is where problems can occur.

Even though the program and image are exactly the same the way that the computer is set up can mean that the picture will appear completely different on each machine. On my computer the image exhibits good contrast and has no apparent color casts. In the UK though it might look a little dark, in the USA slightly blue and in Japan too light and far too green. See Figure 4.1.

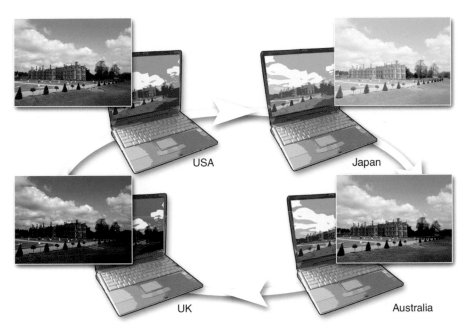

USA Japan

UK Australia

Figure 4.1 Even with exactly the same file and editing program images can appear very different on several machines

Before you start

To help alleviate this problem Adobe has built in to its imaging programs a color management system that will help you set up your machine so that what you see will be as close as possible to what others see. For this reason it is important that you set up your computer using the system before starting to make changes to your images.

The critical part of the process is the calibration of your monitor. To achieve this use the following steps:

1 Make sure that your monitor has been turned on for at least 30 minutes. See Figure 4.2.
2 Check that your computer is displaying thousands (16-bit color) or millions (24- or 32-bit color) of colors. See Figure 4.3.

Figure 4.2 To start the calibration process make sure that your screen has been on for at least 30 minutes

adobe photoshop elements

Figure 4.3 Check to see that your current screen settings will allow the display of millions or 24- or 36-bit colors

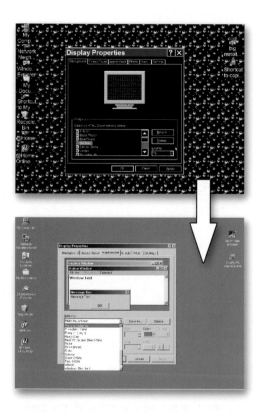

Figure 4.4 Make sure that you have a neutral background color and pattern

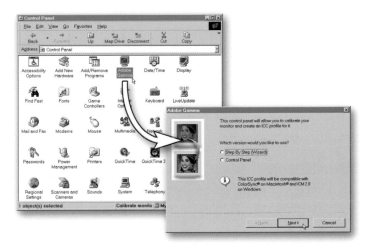

Figure 4.5 Start the Adobe Gamma program

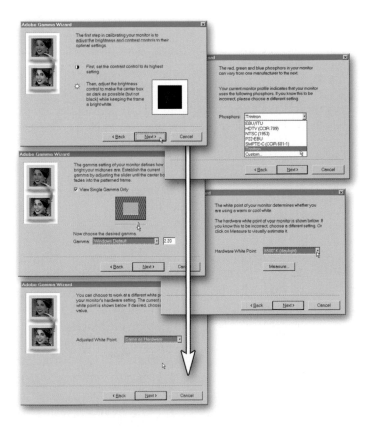

Figure 4.6 Calibrate your screen by proceeding through the steps in the Wizard (Windows) or Assistant (Macintosh)

3 Remove colorful or highly patterned backgrounds from your screen as this can affect your color perception. See Figure 4.4.

4 Start the Adobe Gamma utility. In Windows this is located in control panels or the Program Files/Common Files/Adobe/Calibration folder on your hard drive. On the Macintosh system select the option from the Control Panels section of the Apple menu. See Figure 4.5.

5 Use the step-by-step Wizard (Windows) or Assistant (Macintosh) to guide you through the set-up process. If a default profile was not supplied with your computer contact your monitor manufacturer or check their website for details. See Figure 4.6.

6 Save the profile, including the date in the file name. As your monitor will change with age you should perform the gamma set-up every couple of months. Saving the set-up date as part of the profile name will help remind you when last you used the utility. See Figure 4.7.

Figure 4.7 Save the calibration settings including the date in the file name so that you will remember when you last calibrated your system

Keep in mind that for the color management to truly work all your friends or colleagues who will be using your images must calibrate their systems as well.

Image adjustment and enhancement (see Figure 4.8)

Basic image changes fall into two categories – *adjustment* and *enhancement*.

Image adjustment is mainly concerned with ensuring that the details contained within the picture are presented in a way that is most accurate. This usually means checking to see that the image tones are spread across the full digital spectrum, that the image is not too dark, light or contrasty and that there are no obvious color casts present.

Image enhancement on the other hand deals with techniques designed to emphasize some specific picture elements and de-emphasize others. Changes are made for aesthetic reasons rather than technical ones.

This chapter contains a mixture of adjustment and enhancement techniques. Generally the digital image maker would adjust brightness, contrast and color of the whole image first before moving onto specific adjustments or enhancement techniques.

Figure 4.8 Basic image changes can be grouped into two categories – image adjustment and image enhancement

Brightness

As we saw in Chapter 1 a digital picture is made up of a grid of pixels each with a specific color and brightness. The brightness of each pixel is determined by a numerical value between 0 and 255. The higher the number the brighter the pixel will appear, the lower the value the darker it will be. The extremes of the scale, 0 and 255, represent pure black and

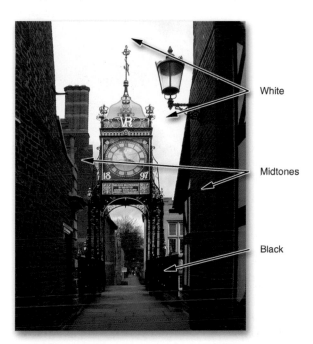

White

Midtones

Black

Figure 4.9 An image with good brightness and contrast will display a good spread of tones between black and white

white and values around 128 are considered midtones. See Figure 4.9.

In a correctly exposed image with good brightness and contrast the tones will be spread between these two extremes. If an image is underexposed then the picture will appear dark on screen and most of its pixels will have values between 128 and 0. See Figure 4.10. In contrast, images that have been overexposed appear light on screen and the majority of their pixels lie in the region between 128 and 255. See Figure 4.11.

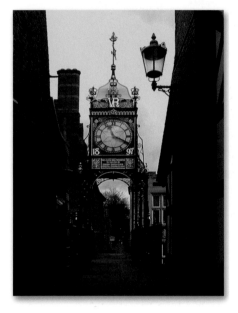 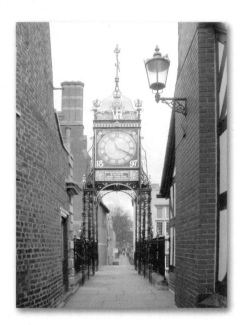

Figure 4.10 An underexposed image appears dark on screen

Figure 4.11 An overexposed image appears light on screen

The best method for correcting these situations is for you to recapture the picture changing the settings on your scanner or camera to compensate for the exposure problem. Good exposure ensures not only a good spread of tones but it also gives you the chance to capture the best detail and quality in your images. It is a misunderstanding of the digital process to excuse poor exposure control by saying 'it's okay I'll fix it in Elements later'. Images that are too dark or light are pictures where vital detail has been lost forever. See Figure 4.12.

Sometimes a reshoot is not possible or a rescan not practical. In these circumstances, or in a situation where only slight changes are necessary, Elements has a range of ways to change the brightness in your images.

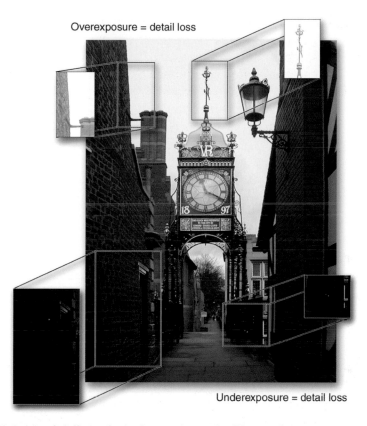

Overexposure = detail loss

Underexposure = detail loss

Figure 4.12 Image details are lost when an image is either under- or overexposed

Brightness/Contrast (Enhance>Brightness/Contrast>Brightness/Contrast)

The Brightness/Contrast command helps you make basic adjustments to the spread of tones within the image. When opened you are presented with a dialog containing two slider controls. Click and drag the slider to the left to decrease brightness or contrast, and to the right to increase the value. See Figure 4.13.

Figure 4.13 The Brightness/Contrast feature is located under the Enhance menu

adobe photoshop elements

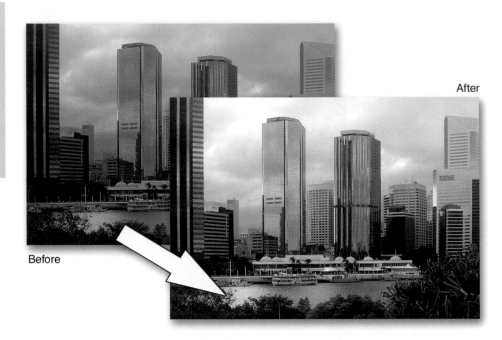

After

Before

Figure 4.14 After adjusting the brightness and contrast of an image the picture will appear clearer and its tone will be spread more evenly

Keep in mind that you are trying to adjust the image so that the tones are more evenly distributed between the extremes of pure white and black. Too much correction using either control can result in pictures where highlight and/or shadow details are lost. As you are making your changes watch these two areas in particular to ensure that details are retained. See Figure 4.14.

Feature summary

1 Select Enhance>Brightness/Contrast>Brightness/Contrast.
2 Move sliders to change image tones.
3 Left to decrease brightness/contrast, right to increase.
4 Click OK to finish.

Auto Contrast (Enhance>Auto Contrast)

The Auto Contrast command can be used as an alternative to the Brightness/Contrast sliders. In this feature Elements assesses all the values in an image and identifies the brightest and darkest tones. These

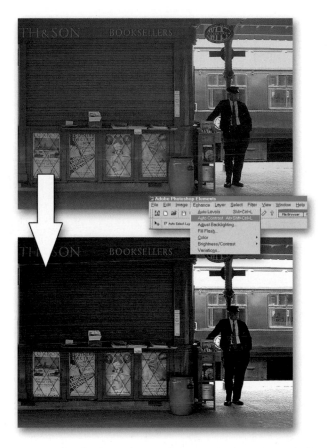

Figure 4.15 Auto Contrast adjusts and spreads image tones automatically

pixels are then converted to white and black and those values in between are spread along the full tonal range. Auto Contrast works particularly well with photographic images. See Figure 4.15.

Feature summary

1 Select Enhance>Auto Contrast.

Auto Levels (Enhance>Auto Levels)

The Auto Levels command is similar to Auto Contrast in that it maps the brightest and darkest parts of the image to white and black. It differs from the previous technique because each individual color channel is treated

adobe photoshop elements

separately. In the process of mapping the tones in the Red, Green and Blue channels dominant color casts can be neutralized. See Figure 4.16. This is not always the case; it depends entirely on the make-up of the image. In some cases the reverse is true, when Auto Levels is put to work on a neutral image a strong cast results. If this occurs Undo (Edit>Undo) the command and apply the Auto Contrast feature instead.

Figure 4.16 Auto Levels adjusts and spreads the tones of each individual color channel. In some pictures, this feature can help to reduce color casts

Feature summary

1 Select Enhance>Auto Levels.

Now that we have changed the brightness and contrast of the image so that the tones are more evenly spread between black and white we can start to look at individual areas or groups of tones that need attention.

Fill Flash (Enhance>Fill Flash)

When you are taking pictures on a bright sunny day or where the contrast of the scene is quite high the shadows in the image can become so dense

that important details are too dark to see. A traditional method used by photographers to lighten the shadows is to capture the scene using a combination of existing light and a small amount of extra light from a flash. The flash illuminates the shadows, in effect 'filling' them with light, hence the name 'fill flash'.

Adobe has taken this traditional technique and incorporated it as an enhancement feature in Elements. You can use this command to lighten the shadow areas of contrasty images. The slider in the feature's dialog controls the degree of lightening. See Figure 4.17.

Figure 4.17 Fill Flash helps to lighten the dark areas of an image

Feature summary

1 Select Enhance>Fill Flash.
2 Move the Lighter slider to change image tones.
3 Click OK to finish.

Adjust Backlighting (Enhance>Adjust Backlighting)

If the foreground or center section of a scene is dark then the exposure system in a digital camera can overcompensate and cause the surrounding area to become too light. Adobe recognized the occurrence of this common problem and included an Adjust Backlighting feature into Elements. By moving the Darker slider in the dialog you can alter the strength of the darkening effect. See Figure 4.18.

Feature summary

1 Select Enhance>Adjust Backlighting.
2 Move the Darker slider to change image tones.
3 Click OK to finish.

Figure 4.18 Backlighting darkens the light areas of an image

Dodge and Burn tools

It is no surprise given Adobe's close relationship with customers who are professional photographers that some of the features contained in both Photoshop and Elements have a heritage in traditional photographic practice. The Dodge and Burn tools are good examples of this. Almost since the inception of the medium, photographers have manipulated the way that their images have printed. In most cases this amounts to giving a little more light to one part of the picture and taking a little away from another. This technique, called 'dodging and burning', effectively lightens and darkens specific parts of the final print.

Adobe's version of these techniques involves two separate tools. See Figure 4.19. The Dodge tool's icon represents its photographic equivalent, a cardboard disk on a piece of wire. This device was used to shade part of the photographic paper during exposure. Having received less exposure the area is lighter in the final print.

When you select the digital version from Elements' toolbox you will notice the cursor change to a circle. Click and drag over your image to lighten the selected areas. The size of the circle is based on the current brush size. This can be changed via the palette in the options bar. Also displayed here are

Brush palette

Dodge/Burn tools

Figure 4.19 The style and size of the Dodge and Burn tools are determined by the currently selected brush

further options to confine the lightening effects to the shadows, midtones or highlights independently. You adjust the amount of lightening by moving the exposure slider or entering a value in the box. See Figure 4.20.

Feature summary – Dodge tool

1 Select Dodge tool from toolbox.
2 Choose brush size from palette in the options bar.
3 Select the group of tones to adjust – highlights, midtones or shadows.
4 Set the strength of the effect via the exposure value.
5 Click and drag cursor over image to lighten.

The Burn tool's attributes are also based on the settings in the options bar and the current brush size, but rather than lightening areas this feature

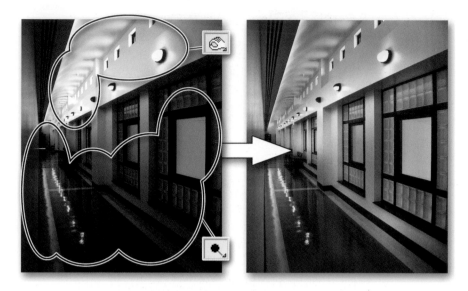

Figure 4.20 Skillful dodging and burning can help improve the appearance of dark and light tones

darkens selected parts of the image. Again you can adjust the precise grouping of tones, highlights, midtones or shadows that you are working on at any one time. See Figure 4.21.

Feature summary – Burn tool

1 Select Burn tool from toolbox.
2 Choose brush size from palette in the options bar.
3 Select the group of tones to adjust – highlights, midtones or shadows.
4 Set the strength of the effect via the exposure value.
5 Click and drag cursor over image to darken.

Figure 4.21 Highlights, shadows and midtones can be dodged and burnt separately

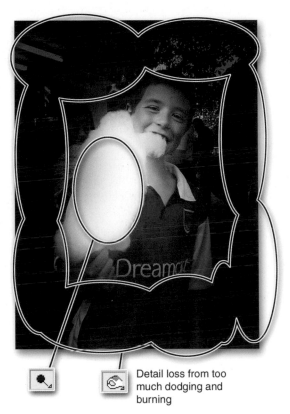

Detail loss from too much dodging and burning

Figure 4.22 Too much dodging and burning is noticeable and can eventually degrade the image rather than improving it

As with a lot of digital adjustment and enhancement techniques it is important to apply dodging and burning effects subtly. Overuse is not only noticeable but you can also lose the valuable highlight and shadow details that you have worked so hard to preserve. See Figure 4.22.

Real life digital imaging: producing digital images for a photographic folio

A regular activity undertaken by many photographers, both amateur and professional alike, is the production of a series of images for presentation. This group of photographs might be centered on a single idea or theme or it might represent a summary of skills and techniques. Whatever the case, a lot of time and effort are put into the

adobe photoshop elements

production of a photographic folio. On the one hand the images must be able to be viewed as a series, each separate piece linked with, and contributing to, the next. But each individual picture must also be strong enough to stand alone.

In the past photographers would spend long hours in the darkroom trying to ensure that all the variables of chemistry, time, exposure and paper were consistent so that each of the prints in the series would 'feel' similar. More recently image makers have started to use the 'digital darkroom' to give their pictures a unified look. Even if the photographs start life as a slide or negative, the enhancing and printing stages are being handled digitally rather than traditionally.

Kathryn Lyndsey is a photographer whose recent images are a good example of this new way of working. When producing a recent series of photographs she chose to shoot the images using a film-based camera and then complete the production process digitally. She says 'Working digitally gives me more freedom to be creative. I can work and rework an image making small adjustments that are not as easy to achieve in the darkroom. I feel less restricted and more in control.' See Figures 4.23 and 4.24.

Figures 4.23–4.24 Photographers like Kathryn Lyndsey are starting to use digital as a way of ensuring quality and consistency in their work. (Source: Kathryn Lyndsey)

Web link: Perform the same adjustments on the example images from the book's website, before producing your own photographic prints.

Captions to Figure 4.25 (see page 56)

1 Kathryn's images are shot using traditional film cameras
2 When processed she searches through the negatives to find the most suitable images
3 The candidate photographs are then converted to digital using a film scanner
4 The raw files are previewed on screen and examined carefully to identify areas that need adjusting
5 Basic manipulations such as changing orientation and altering brightness and contrast are made first
6 Next, parts of the image are darkened and lightened using the Dodge and Burn tools
7 In some images Kathryn adds color and texture to black and white pictures using the Hue/Saturation command and Texture filters. See Chapter 5 for more details of these techniques
8 As a proofing step Kathryn outputs her work to an inkjet printer first to check color and how each of the images appears
9 The final step is to save the files to CD and send them off to a local professional photographic laboratory that will print the folio images on color photographic paper

Strange colors in my images

Our eyes are extremely complex and sophisticated imaging devices. Without us even being aware they adjust to changes in light color and level. For instance, when we view a piece of white paper outside on a cloudy day, indoors under a household bulb or at work with fluorescent lights, the paper appears white. Our eyes adapt to each different environment.

Unfortunately digital sensors including those in our cameras are not as clever. If I photographed the piece of paper under the same lighting conditions, the pictures would all display a different color cast. Under fluorescents the paper would appear green, lit by the household bulb it would look yellow and when photographed outside it would be a little blue. See Figure 4.26.

This situation occurs because camera sensors are designed to record images without casts in daylight only. As the color balance of the light for our three examples is different to daylight, that is, some parts of the spectrum are stronger and more dominant than others, the pictures record with a cast. Camera manufactures are addressing the problem by

adobe photoshop elements

Capture pictures on film

Select images

Scan negatives

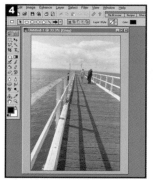
Preview digital files

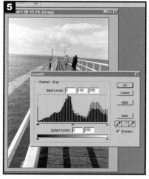
Make basic changes

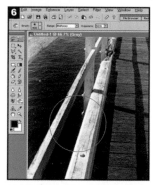
Dodge and burn selected areas

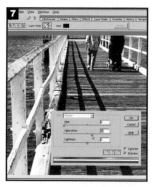
Add color and texture

Review proofs of images

Save files to CD-ROM

Figure 4.25 (Full captions provided on page 55)

including 'auto white balance' functions in their designs. These features attempt to adjust the captured image to suit the lighting conditions it was photographed under, but even so, some digital pictures will arrive at your desktop with strange color casts. See Figure 4.27.

Fluorescent

Household Bulb

Candlelight

Daylight

Figure 4.26 The dominant color in an image changes when it is shot under different light sources

Auto white balance control

Figure 4.27 Some cameras include an auto white balance feature designed to compensate for different light sources

Color Cast (Enhance>Color>Color Cast)

To help solve this problem Adobe has included the Color Cast command in Elements. This function is designed to be used with images that have areas that are meant to be either white, gray or black. By selecting the feature you can click onto the neutral area and all the colors of the image will be changed by the amount needed to make the area free from color casts. This command works particularly well if you happen to have white, gray or black in your scene. See Figure 4.28. Some image makers include a gray card in the corner of scenes that they know are going to produce casts in anticipation of using Color Cast to neutralize the hues later.

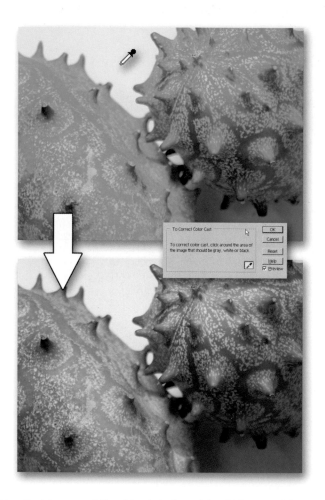

Figure 4.28 Color Cast is a specialized tool designed to rid images of unwanted color tinges

Feature summary

1 Select Enhance>Color>Color Cast.
2 Use the Eyedropper tool to click on a part of the image that is meant to be either a neutral white, gray or black.
3 If you are unhappy with the results click the Reset button to start again.
4 Click OK when the cast has been removed.

Keep in mind that this command produces changes based on the assumption that what you are clicking with the eyedropper is meant to be neutral – even amounts of red, green and blue. In practice it is not often that images have areas like this. For this reason Elements contains another method to help rid your images of color casts.

Variations (Enhance>Variations)

An alternative to Color Cast is the Variations command. This feature is based on a color wheel, which is made up of the primary colors red, green and blue and their complementaries, cyan, magenta and yellow. See Figure 4.29. Increasing the amount of one color in an image automatically decreases its complementary. Put simply, increasing red will decrease

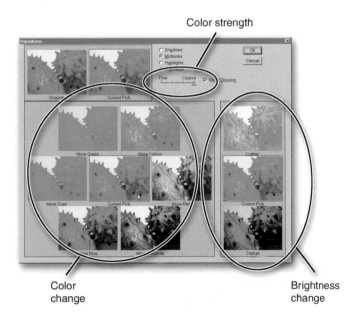

Figure 4.29 The Variations feature gives the user more control over color changes in the image

cyan, increasing green will reduce magenta and increasing blue will lessen yellow. Understanding this link will help you use the Variations command. In addition to changes to color this feature also gives options to change the picture's brightness and saturation.

The Variations dialog is divided into three sections. The top left contains two thumbnails that represent how your image looked before changes and its appearance after. On the right-hand side are a further three images for changing brightness. Clicking the top picture will lighten the image, clicking the bottom will darken it.

The main part of the box is taken up with a star pattern of seven images. Those around the outside represent the picture with specific colors added. Clicking on any of these thumbnails will change your 'current pick' or central picture by adding the color chosen. To add a color to your image, click on a suitably colored thumbnail. To remove a color click on its opposite.

The 'fine/coarse' slider controls the strength of the color changes. You can also select the grouping of tones that are altered by your selections. In this way highlights, midtones and shadows can all be adjusted independently.

Feature summary

1 Select Enhance>Variations.
2 Turn on the 'Show Clipping' function to highlight the areas of your image that will be changed to pure white or black by your adjustments.
3 Choose the tones you want to change (shadows, midtones or highlights) or alternatively select saturation.
4 Adjust the fine/coarse slider to set the strength of each change.
5 Click on the appropriate thumbnails to make changes to your image.
6 Click OK to finish.

Red Eye Brush

Using the built-in flash in your camera is a great way to make sure that you can keep photographing in any light conditions. One of the problems with flashes that are situated very close to the lens is that portrait pictures, especially when taken at night, tend to suffer from 'red eye'. The image might be well exposed and composed but the sitter has glowing red eyes. This occurs because the light from the flash is being reflected off the back of the eye.

Adobe recognized that a lot of modern digital cameras contain the type of flashes that can cause this problem and developed a specialist tool to help retouch these images. Called the Red Eye Brush, it changes crimson color in the center of the eye for a more natural looking black. To use on your own images, pick the tool from the toolbox, select the brush size and type, then push the default colors button in the options bar and then click on the red section of the eyes. See Figure 4.30.

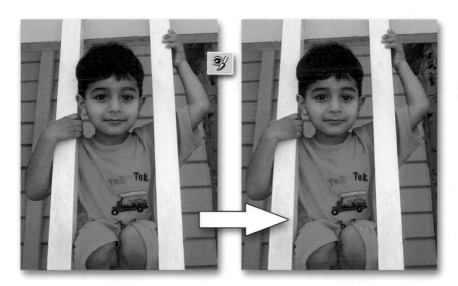

Figure 4.30 The Red Eye Brush is designed to eliminate the 'devil like' eyes that result from using the in-built flash of some cameras

Though designed specifically for this purpose, the tool can also be used for changing other colors. To achieve this click on the 'current' color swatch and use the eyedropper to sample the color you wish to change. Next click on the 'Replacement' swatch to pick the hue that will be used as a substitute. Now when the brush is dragged over a 'current' color it will be changed to the 'replacement' hue.

The tolerance slider controls how similar to the current color a pixel must be before it is replaced. Low values restrict the effect to precisely the current color, higher values replace a broader range of dissimilar hues.

Feature summary

1 Select Red Eye Brush from the toolbox.
2 Choose brush size and type from the options bar.

3 Click the Default Colors button to remove red eye or select your own Current and Replacement colors.
4 Adjust the Tolerance slider to suit the image.
5 Drag the brush over the area to be changed.

Filters

The filters contained within image-editing programs are capable of producing truly stunning effects. Digital filters are based on the traditional photographic version, which is placed in front of the lens of the camera to change the way the image is captured. Now with the click of a button it is possible to make extremely complex changes to our images almost instantaneously – changes that a few years ago we couldn't even imagine.

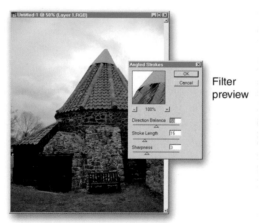

Filter preview

Figure 4.31 Most filters are supplied with a preview and settings dialog that allows the user to view changes before committing them to the full image

The filters in Adobe Photoshop Elements can be found grouped under a series of subheadings based on their main effect or feature in the Filter menu. Selecting a filter will apply the effect to the current layer or selection. Some filters display a dialog that allows the user to change specific settings and preview the filtered image before applying the effect to the whole of the picture. See Figure 4.31. This can be a great time saver as filtering a large file can take several minutes. If the preview option is not available then as an alternative, make a partial selection of the image using the Marquee tool first and use this to test the filter. Remember filter changes can be reversed by using the undo feature.

The number and type of filters available can make selecting which to use a difficult process. To help with this decision Elements contains a Filter Browser feature (Window>Show Filter Browser) that displays thumbnail versions of different filter effects. See Figure 4.32. The filters previewed at any one time can be changed by altering the selection in the pop-up menu at the top of the palette.

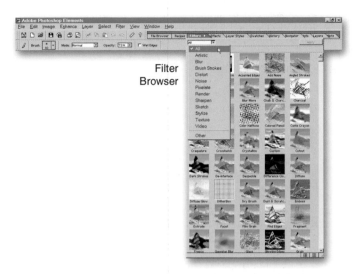

Figure 4.32 The Filter Browser gives users a good idea of the types of changes that a filter will make to an image

Feature summary

1 Check to see that you have selected the layer that you wish to filter.
2 Select Window>Show Filter Browser or click on the Filters tab in the Palette Well to display the Filters palette.
3 Select and double click the icon to call up the dialog box for that filter.
4 Adjust settings in the preview dialog (if available for the particular filter chosen).
5 Click OK to finish.

To give you a head start with your filtering I have applied some of the most common filters to a base image. The results along with the filter preview/ settings and dialogs are printed on the next couple of pages. See Figures 4.33 to 4.44.

The ten commandments for filter usage

1 *Subtlety is everything.* The effect should support your image not overpower it.
2 *Try one filter at a time.* Applying multiple filters to an image can be confusing.

Figure 4.33 Artistic>Colored Pencil

Figure 4.34 Blur>Radial Blur

Figure 4.35

Brush Strokes>Spatter

Figure 4.36

Distort>Liquify

Figure 4.37 Noise>Add Noise

Figure 4.38 Pixelate>Pointillize

Figure 4.39 Render>Lighting Effects

Figure 4.40 Sharpen>Unsharp Mask

adobe photoshop elements

Figure 4.41 Sketch>Bas Relief

Figure 4.42 stylize>Tiles

Figure 4.43 Texture>Craquelure

Figure 4.44 Stylize>Glowing Edges

3 *View at full size.* Make sure that you view the effect at full size (100%) when deciding on filter settings. (Double click the Zoom tool in the toolbar.)

4 *Filter a channel.* For a change, try applying a filter to one channel only – Red, Green or Blue.

5 *Print to check effect.* If the image is to be viewed as a print, double check the effect when printed before making final decisions about filter variables.

6 *Fade strong effects.* If the effect is too strong try fading it. Apply the filter to a duplicate image layer that is above the original. Then reduce the opacity of this layer so the unfiltered original shows through.

7 *Experiment.* Try a range of settings before making your final selection.

8 *Select then filter.* Select a portion of an image and then apply the filter. In this way you can control what parts of the image are affected.

9 *Different effects on different layers.* If you want to combine the effects of different filters try copying the base image to different layers and applying a different filter to each. Combine effects by adjusting the opacity of each layer.

10 *Did I say that subtlety is everything?!*

Hints (Window>Show Hints)

In developing Elements Adobe has designed a range of learning aids that can help you increase your skills and understanding of the program. One such feature is the Hints palette, which is located in the Palette Well or under the Window menu. When open this window shows information about the tool or menu currently selected. See Figure 4.45. The Hints function is an extension to the Help system and offers the user a more detailed explanation of the item by clicking the 'More Help' button.

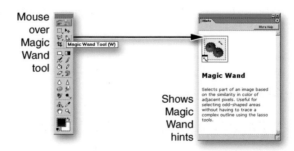

Figure 4.45 The Hints palette helps users by providing specific information about tools, menus and features

Feature summary

1 Select Window>Show Hints or click on the Hints tab in the Palette Well to display the window.
2 Move mouse over, or select, the tool or menu item you need help with.
3 Click the More Help button to see extra help information about the item.

Recipes (Window>Show Recipes)

The Recipes palette is an in-built tutorial system designed to take you step by step through a range of common enhancement and editing activities. To make best use of the feature keep the window open whilst performing each step on your own image. See Figure 4.46.

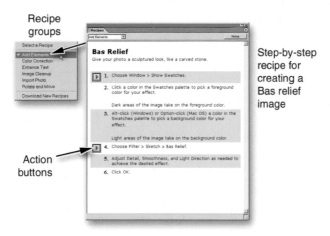

Figure 4.46 The Recipe palette provides step-by-step tutorials covering major adjustment and enhancement techniques

Feature summary

1 Select Window>Show Recipes or click the Recipes tab in the Palette Well.
2 Choose a recipe category and pick the recipe to use.
3 Work through the step-by-step instructions.

Real life digital imaging: real estates go digital

Adam Djordjevic is a busy real estate agent in an inner city firm. A lot of his business is based on communicating ideas and images with his clients. He finds that good images of properties are crucial for establishing common ground and understanding what style and type of dwelling his customers are looking for.

For this reason taking pictures of houses and apartments is an integral part of the selling process. The images can then be used in a range of marketing activities including the showcase in the office window, advertisements in local and national papers and on the company's website. See Figure 4.47.

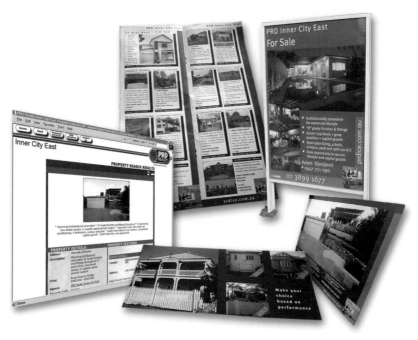

Figure 4.47 Images shot with a digital camera are used for all the marketing products produced by the real estate office

Adam feels that acquiring the images digitally makes it easier to use them in a range of formats. 'We can print them for in the window, use them in "open house" literature, send them to the papers for ads and also pop them onto the website. No problem! Before we had to muck around with negatives and prints, the same digital file can be used for all our marketing needs.'

Web link: Use the templates and example images from the book's website to create your own real estate flyers and posters.

Captions to Figure 4.48 (see page 74)

1 One of the real estate team photographs the property making sure that all the important features of the house are clearly shown. As there is no film or processing costs involved many pictures can be taken and the best selected for use

2 Back at the office the images from the camera are downloaded onto the computer. In this case the camera is connected to the computer using a special cradle

3 The brightness, contrast and color of the photographs are adjusted. The image is saved at the full resolution at which it was captured. This file will be used for all print applications. A further copy is then saved at a resolution suitable for web and email distribution

4 Emails with attached images and text are sent to the papers, printers and sign makers. Each of these companies will use the digital files for laying out of advertisements, brochures and signs

5 The task of updating the website to include the new listing is handled in-house. A template of the new page is automatically produced and the images and text are pasted into position. After checking the new page is uploaded to the website

6 Meanwhile the sign maker has faxed back a draft of the proposed sign. Adam checks the details and sends the corrections back to be fixed

7 The printed window card arrives and is placed in a plastic mount, which is then hung in the display window

8 Later that week the local newspaper features an editorial about the property using details and the digital images supplied online by Adam

9 The day the paper is distributed the sign arrives and is hurriedly put in place in front of the property to make the most of the publicity

Photograph house with digital camera

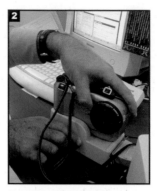

Download pictures

Adjust brightness and color

Attach image files to emails

Update website with new images

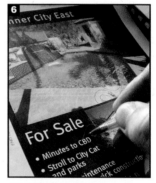

Review sign details

Produce window card

Place newspaper advertisement

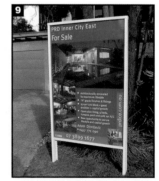

Erect completed house sign

Figure 4.48 (Full captions provided on page 73)

5 Advanced Techniques

The Brightness/Contrasts control is a great way to start to change the tones in your images but as your skill and confidence increase you might find that you want a little more control. Adobe included the Histogram feature and the Levels control from Photoshop in Elements for precisely this reason.

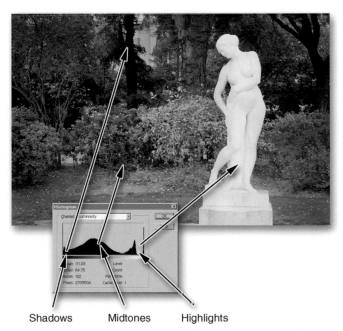

Shadows Midtones Highlights

Figure 5.1 The Histogram feature provides information about the spread of pixel tones within your image

Advanced tonal control

The first step in taking charge of your pixels is to become aware of where they are situated in your image and how they are distributed between black and white. The Histogram palette (Image>Histogram) displays a graph of all the pixels in your image. The left-hand side represents the black values, the right the white end of the spectrum. As we already know, in a 24-bit image there is a total of 256 levels of tone possible from black to white – each of these values is represented on the graph. The number of pixels in the image with a particular brightness or tone value is displayed on the graph by height. See Figure 5.1.

Knowing your images

After a little while of viewing the histograms of your images you will begin to see a pattern in the way that certain styles of photographs are represented. Overexposed pictures will display a large grouping of pixels to the right end of the graph, whereas underexposure will be represented by most pixels bunched to the left. Flat images or those taken on an

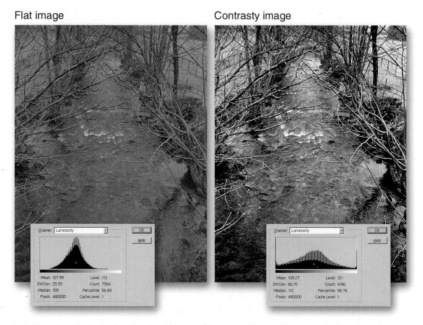

Figure 5.2 Pixels are bunched together in the middle of the graph for flat images. The pixels are spread right out to the left and right edges for contrasty pictures

Under exposed image Over exposed image

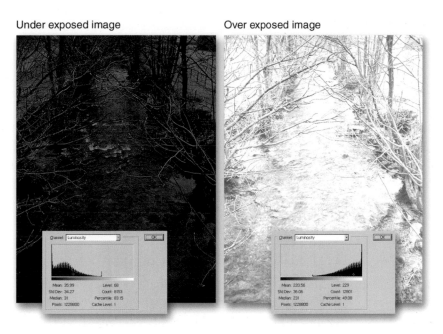

Figure 5.3 The pixels are bunched to the left end of the graph for underexposed images and to the right end for overexposed ones

overcast day will show all pixels grouped around the middle tones and contrasty pictures will display many pixels at the pure white and black ends of the spectrum. See Figures 5.2 and 5.3.

Previously we have fixed these tonal problems by applying one of the automatic correction features, such as Auto Contrast or Auto Levels, found in Elements. Both these commands remap the pixels so that they sit more evenly across the whole of the tonal range of the picture. Viewing the histogram of a corrected picture will show you how the pixels have been redistributed. See Figure 5.4. If you want to take more control of the process than is possible with the auto solutions, open the Levels dialog.

Levels (Enhance>Brightness/Contrast>Levels)

Looking very similar to the histogram this feature allows you to interact directly with the pixels in your image. As well as a graph, the dialog contains two slider bars. The one directly beneath the graph has three triangle controls for black, midtones and white and represents the input values of the picture. The slider at the bottom of the box shows output settings and contains black and white controls only. See Figure 5.5.

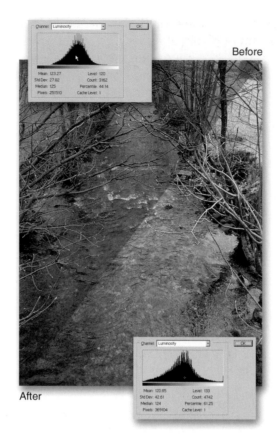

Before

After

Figure 5.4 The auto levels or contrast functions redistribute pixels in the graph between the black and white points

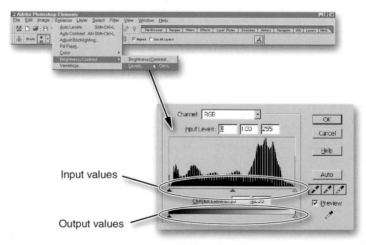

Input values

Output values

Figure 5.5 The levels control allows you to interactively control the spread of pixels within your image

To adjust the pixels, drag the input shadow and highlight controls until they meet the first set of pixels at either end of the graph. When you click OK the pixels in the original image are redistributed using the new white and black points. Altering the midtone control will change the brightness of the middle values of the image and moving the output black and white points will flatten, or decrease, the contrast. Clicking the Auto button is like selecting Enhance>Auto Levels from the menu bar.

Use the following guide to help you make tonal adjustments for your images using levels – see Figures 5.6 and 5.7.

To *increase contrast* – Move the input black and white controls to meet the first group of pixels in the graph.

To *decrease contrast* – Move the output black and white points towards the center of the slider.

To *make middle values darker* – Move the input midtone control to the right.

To *make middle values lighter* – Move the input midtone control to the left.

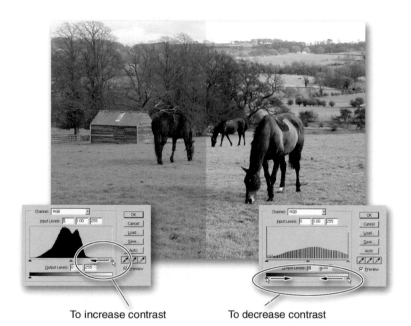

To increase contrast To decrease contrast

Figure 5.6 Increase contrast by moving the input black and white sliders towards the center. Decrease contrast by moving the output black and white sliders towards the center

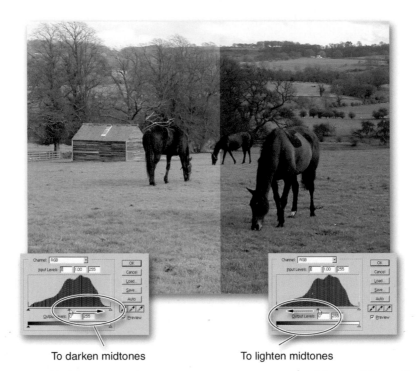

To darken midtones To lighten midtones

Figure 5.7 Darken middle values in the image by moving the midtone slider to the right; lighten them by moving the same slider to the left

Feature summary

1 Select Enhance>Brightness/Contrast>Levels.
2 Change contrast and midtone values by adjusting input and output sliders, or
3 Select OK to finish.

Pegging black and white points

On the right-hand side of the dialog is a set of three eyedropper buttons used for sampling black, gray and white pixels in your image. Designed to give you ultimate control over the tones in your image, these tools are best used in conjunction with the Info palette (Window>Show Info). See Figure 5.8.

To use, make sure that the Info palette is visible and then select the black point eyedropper. Locate the darkest point in the picture by moving the dropper cursor over your image and watching the values in the Info

First readout

Second readout

Sample position

Figure 5.8 The Show Info dialog displays a readout of the precise values of a group of pixels

palette. Your aim is to find the values as close to 0 as possible. By clicking on the darkest area you will automatically set this point as black in your graph. Next select the white point eyedropper, locate the highest value and click to set. With highlight and shadow values both pegged all the values in the picture will be adjusted to suit. See Figures 5.9 and 5.10. When sampling white areas you should avoid specular highlights such as the shine from the surface of a metallic object, as these parts of the picture contain no printable details, and so rightly should be burnt out.

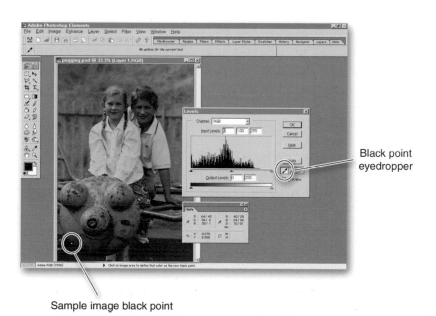

Black point eyedropper

Sample image black point

Figure 5.9 Locate the darkest point in the image and peg this as your black

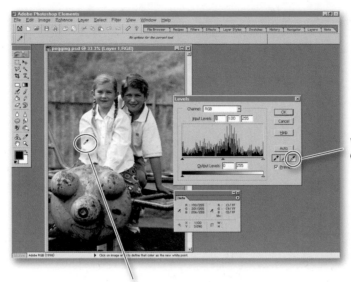

White point
eyedropper

Sample image white point

Figure 5.10 Find the lightest area of the picture that is not a specular highlight and peg this as your white point

The gray point eyedropper performs in a similar manner to the color cast command. With the tool selected, the user clicks on an area in the picture that should be a neutral gray. The color of the area is changed to neutral gray or equal amounts or red, green and blue, changing with it all the other pixels in the image. This tool is particularly useful for neutralizing color casts.

Feature summary

1 Select Window>Show Info.
2 Select Enhance>Brightness/Contrast>Levels.
3 Peg highlights and shadow areas using the level's eyedropper tools and values in the Info palette.
4 Select OK to finish.

Advanced color control

In traditional imaging it is very difficult to manipulate the hues in an image. Thankfully, this is not the case in digital picture making. Fine control over

color intensity and location is an integral part of the new technology. Apart from the Variations and Color Cast features that we looked at in the last chapter Elements also contains a specialized Hue/Saturation command.

Hue/Saturation (Enhance>Color>Hue/Saturation)

To understand how this feature works you will need to think of the colors in your image in a slightly different way. Rather than using the three-color model (Red, Green, Blue) that we are familiar with, the Hue/Saturation control breaks the image into different components – Hue or color, Saturation or color strength and Lightness (HSL). See Figure 5.11.

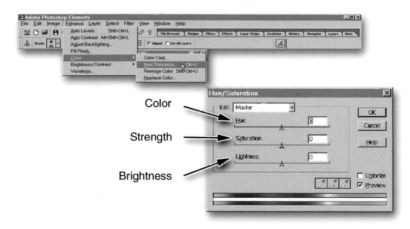

Figure 5.11 The Hue/Saturation control provides control over the color within your image

The dialog itself displays slider controls for each component allowing the user to change each factor independently of the others. Moving the Hue control along the slider changes the dominant color of the image. From left to right the hue changes are represented in much the same way as colors in a rainbow. Alterations here will provide a variety of dramatic results most of which are not realistic and should be used carefully. See Figure 5.12.

By selecting the Colorize option and then moving the hue control it is possible to simulate sepia or blue toned prints. The option converts a colored image to a monochrome made up of a single dominant color and black and white. See Figure 5.13.

Before After

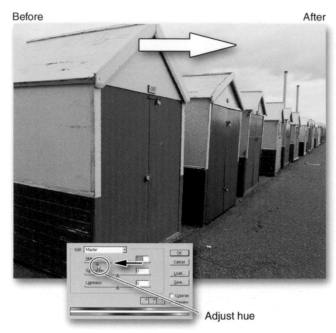

Adjust hue

Figure 5.12 Moving the Hue slider changes the dominant colors in the image

Before After

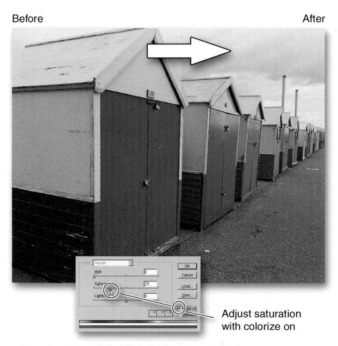

Adjust saturation
with colorize on

*Figure 5.13 Selecting the Colorize option changes the image to a monochrome,
containing tones made up of one main color, white and black*

Moving the saturation slider to the left gradually decreases the strength of the color until the image is converted to a grayscale. In contrast, adjusting the control to the right increases the purity of the hue and produces images that are vibrant and dramatic. See Figure 5.14.

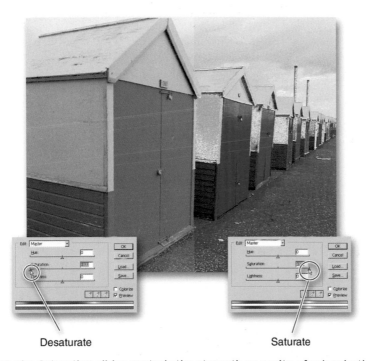

Desaturate Saturate

Figure 5.14 The Saturation slider controls the strength or purity of colors in the picture

The lightness changes the density of the image and works the same way as the brightness slider in the Brightness/Contrast feature. You can use this feature to make slight adjustments when a color change darkens or lightens the midtones of the image.

Feature summary

1 Select Enhance>Color>Hue/Saturation.
2 Select Colorize option to make toned prints.
3 Change Hue, Saturation and Lightness by adjusting sliders.
4 Select OK to finish.

Variations (Enhance>Variations)

The Variations command that we looked at in the last chapter can also be used to convert full color images to toned monochromes. First, change your color image to grayscale (Image>Mode>Grayscale), then change the grayscale picture back to RGB Color (Image>Mode>RGB Color). Your image will still appear to be a grayscale but now color can be added. Open the Variations command (Enhance>Variations) and tone your picture by clicking on the appropriate thumbnails. For some users this method might be a little easier to use than the Hue/Saturation command as the results and color alternatives are previewed and laid out clearly. See Figure 5.15.

Feature summary

1 Open color image.
2 Select Image>Mode>Grayscale to convert your image.
3 Select Image>Mode>RGB Color.
4 Select Enhance>Variations.
5 Adjust strength of the color changes using the Fine/Coarse slider.
6 Pick the thumbnails to change image color.
7 Check progress by viewing the Current/Original thumbnails.
8 Click OK to finish.

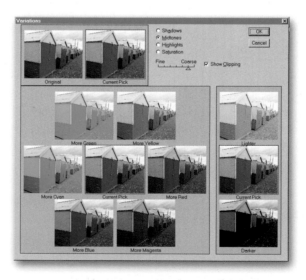

Figure 5.15 The Variations control provides a color wheel of thumbnails that can be used to remove, or add, color casts to your pictures

Sponge

It is possible to draw a viewer's attention to a particular part of an image by increasing its saturation. The contrast makes the saturated part of the picture a new focal point. The effect can be increased greatly by desaturating the areas around the focal point. The Sponge tool is designed to make local changes to color within an image. It can be used to saturate or desaturate, and in grayscale mode it will even decrease or increase contrast. As with most other tools size and mode can be changed in the options bar. See Figure 5.16.

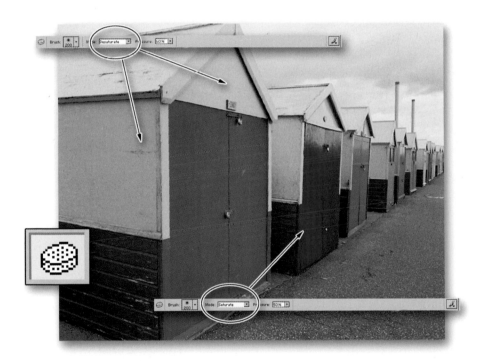

Figure 5.16 The Sponge tool can be used to selectively increase or decrease the saturation of parts of the image

Feature summary

1 Pick the Sponge tool from the toolbox.
2 Select brush size and type from options bar.
3 Select the mode to use – Saturate or Desaturate.
4 Drag over the image part to change.

Posterize (Image>Adjustments>Posterize)

The Posterize feature reduces the number of colors within an image. This produces a graphic design type illustration with areas of flat color from photographic originals. This type of image has very little graduation of tone; instead, it relies on the strength of the colors and shapes that make up the image for effect. The user inputs the number of tones for the images and Elements proceeds to reduce the total palette to the selected few. See Figure 5.17.

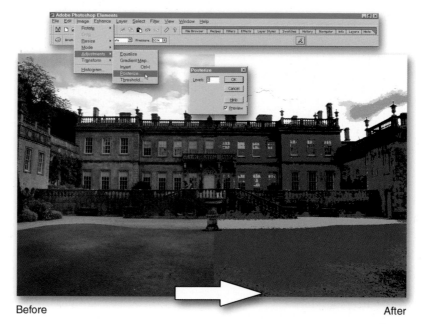

Before After

Figure 5.17 The Posterize feature is used to reduce the total number of colors in an image

Feature summary

1 Select Image>Adjustments>Posterize.
2 Input the number of levels required.
3 Select OK to finish.

Invert (Image>Adjustments>Invert)

The Invert command produces a negative version of a positive image. The feature literally swaps the values of each of the image tones. When

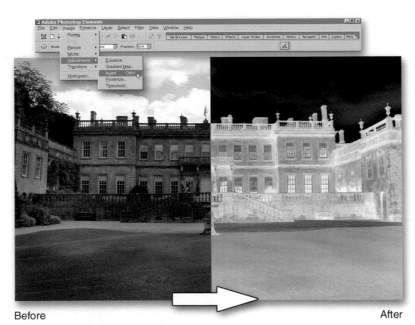

Before After

Figure 5.18 The Invert command reverses all image colors and tones

used on a grayscale image the results are similar to a black and white negative. However, this is not true for a color picture, as the inverted picture will not contain the orange 'mask' found in color negatives. See Figure 5.18.

Feature summary

1 Select Image>Adjustment>Invert.

Sharpening techniques

Sometimes during the image capture process the picture loses some of the subject's original clarity. This can be especially true if you are scanning small prints or negatives at high resolutions. To help restore some of this lost clarity it is a good idea to get into the habit of applying sharpening to images straight after capture. Elements provides a variety of filters as well as a specialized tool just for this purpose.

I should say from the outset that although these features will improve the appearance of sharpness in an image it is not possible to use these

tools to 'focus' a picture that is blurry. In short, sharpening won't fix problems that arise from poor camera technique; the only solution for this is to ensure that images are focused to start with. That said let's look at the options in Elements.

Sharpen and Sharpen More (Filter>Sharpen>Sharpen or Sharpen More)

Most digital sharpening techniques are based on increasing the contrast between adjacent pixels in the image. When viewed from a distance this change makes the picture appear sharper. These filters are designed to apply basic sharpening to the whole of the image and the only difference between the two is that Sharpen More increases the strength of the sharpening effect. See Figure 5.19.

No Sharpening Filter>Sharpen>Sharpen Filter>Sharpen>Sharpen More

Figure 5.19 The basic sharpening filters

Sharpen Edges (Filter>Sharpen>Sharpen Edges)

One of the problems with sharpening is that sometimes the effect is detrimental to the image causing areas of subtle color or tonal change to become coarse and pixellated. These problems are most noticeable in image parts such as skin tones and smoothly graded skies. To help solve this problem, Adobe included another filter in Elements, Sharpen Edges, which concentrates the sharpening effects on the edges of objects only. Use this filter when you want to stop the effect being applied to smooth image parts. See Figure 5.20.

Feature summary

1 Select Filter>Sharpen>Sharpen or Sharpen More for standard sharpening.
2 Select Filter>Sharpen>Sharpen Edges to isolate the sharpening effects to the edges in the image.

Unsharp Mask (Filter>Sharpen>Unsharp Mask)

This feature is based on an old photo-graphic technique for sharpening images that used a slightly blurry mask to increase edge clarity. The digital version offers user control over the sharpening process via three sliders – Amount, Radius and Threshold. By careful manipulation of the settings of each control the

Filter>Sharpen>Sharpen Edges

Figure 5.20 The Sharpen Edges filter restricts the effect to the edges of image parts only

sharpness of images destined for print or screen can be improved. Beware though, too much sharp-ening is very noticeable and pro-duces problems in the image such as edge halos that are very difficult to correct later. See Figure 5.21.

The *Amount* slider controls the strength of the sharpening effect. Values of 50% to 100% are suit-able for low-resolution pictures whereas settings between 150% and 200% can be used on images with a higher resolution. See Figure 5.22.

The *Radius* slider value deter-mines the number of pixels around the edge that is affected by the

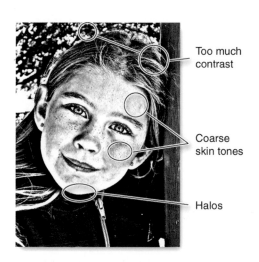

Too much contrast

Coarse skin tones

Halos

Figure 5.21 Overuse of the Unsharp Masking filter can lead to irreversible problems

sharpening. A low value only sharpens edge pixels. Typically values between 1 and 2 are used for high-resolution image settings of 1 or less for screen images. See Figure 5.23.

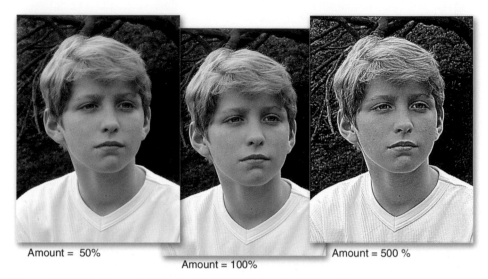

Amount = 50%

Amount = 100%

Amount = 500 %

Figure 5.22 The Amount slider controls the strength of the effect

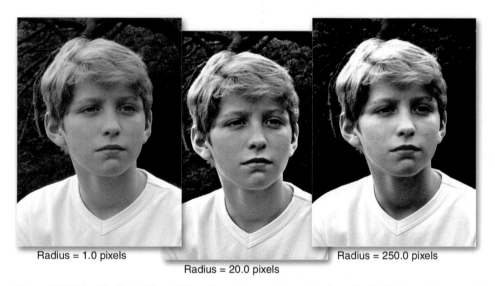

Radius = 1.0 pixels

Radius = 20.0 pixels

Radius = 250.0 pixels

Figure 5.23 The Radius slider determines the number of edge pixels that are sharpened

The *Threshold* slider is used to determine how different the pixels must be before they are considered an edge and therefore sharpened. A value of 0 will sharpen all the pixels in an image whereas a setting of 10 will only apply the effect to those areas that are different by at least 10 levels or more from their surrounding pixels. To ensure that no sharpening occurs in sky or skin tone areas set this value to 8 or more. See Figure 5.24.

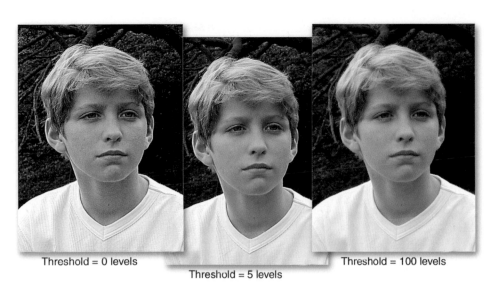

Threshold = 0 levels Threshold = 100 levels

Threshold = 5 levels

Figure 5.24 The Threshold slider controls the point at which the effect is applied

Before using the Unsharp Mask filter make sure that you are viewing your image at 100%. If you intend to print the sharpened image, make test prints at different settings before deciding on the final values for each control. Repeat this exercise for any pictures where you want the best quality, as the settings for one file might not give the optimum results for another picture that has a slightly higher or lower resolution.

Feature summary

1 Select Filter>Sharpen>Unsharp Mask.
2 Adjust Amount slider to control strength of filter.
3 Adjust Radius slider to control the number of pixels surrounding an edge that are included in the effect.
4 Adjust Threshold slider to control what pixels are considered edge and therefore sharpened.

Sharpen/Blur tools

In addition to using a filter to sharpen your image it is also possible to make changes to specific areas of the picture using one of the two sharpening tools available. The Blur and Sharpen tools are located in the

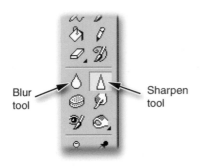

Blur tool

Sharpen tool

Figure 5.25 The Blur and Sharpen tools can be used to apply sharpening to specific areas within an image

Elements toolbox. See Figure 5.25. The size of the area they change is based on the current brush size. The strength of the effect is controlled by the Pressure value found in the options bar.

As with the Spray Brush tool the longer you keep the mouse button down the more pronounced the effect will be. These features are particularly useful when you want to change only small parts of an image rather than the whole picture. See Figure 5.26.

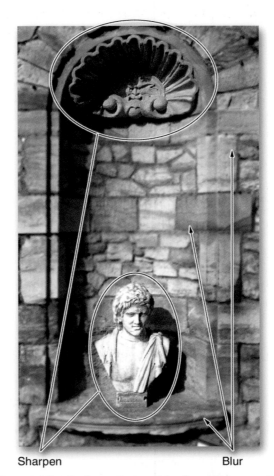

Sharpen Blur

Figure 5.26 The Sharpen/Blur tools can be used to direct the eye of the viewer by making some areas of an image more prominent than others

Feature summary

1 Select the Blur or Sharpen tool from the toolbox.
2 Adjust the size and style of the tool with the Brush palette in the options bar.
3 Change the strength of the effect by altering the Pressure setting.
4 Blur or sharpen areas of the image by clicking and dragging the tool over the picture surface.
5 Increase the change in any one area by holding the mouse button down.

Real life digital imaging: business and graphics combine

Gone are the days when business presentations are made up of a few sheets of columns of dry figures all neatly contained in a plain manila folder. Now managers of all types of companies are expected to deliver their reports with a little more pizzazz and certainly more graphical content. Most of these presentations are put together in slide show type packages like Corel Presentations and consist of a combination of written information and graphical content. Though very sophisticated in themselves most slide show programs contain no, or very limited, image-editing abilities. Technology savvy managers are now using packages like Elements in conjunction with their presentation software to produce interesting and dynamic business reports. See Figure 5.27.

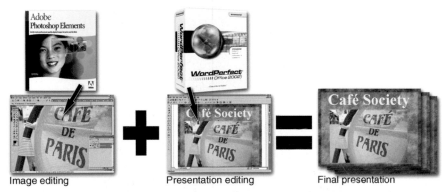

Image editing Presentation editing Final presentation

Figure 5.27 Image-editing programs can combine with presentation packages to allow users to produce dynamic and graphic business presentations

Web link: Put together a simple digital slide presentation using the example business graphics on the book's website.

Captions to Figure 5.28 (see page 97)

1 When generating quality business graphics it is important to make sure that the image component supports the business ideas and does not distract from them. For this reason a lot of managers start the process with a few design drawings

2 As the presentation process involves the delivery of a series of 'electronic' slides, putting together a storyboard, similar to those used in the film industry, is the next step in the design process

3 With the design complete a list of visual elements, or props, that need to be photographed, or scanned, is compiled

4 The props are then captured being sure to take several images from different directions or angles so that there is more choice later in the process

5 Next the images are downloaded to the computer and imported into Elements. Brightness, contrast, color and sharpness are adjusted

6 The background is removed from the objects using the Background Eraser tool and a Cutout filter (Filters>Artistic>Cutout) applied to give the props a more graphic appearance

7 The presentations program is started and the background, text and graph components of the slide composed

8 The finished graphic components are then copied in Elements (Select>All, then Edit>Copy) and pasted (Edit>Paste) into the presentation program

9 The graphics are then resized and arranged to fit the background and text content. The final slide is saved as part of the full presentation

Retouching techniques

More than enhancing existing detail these techniques are designed to rid images of visual information like dust and scratches that can distract from the main picture.

Dust and Scratches (Filter>Noise>Dust and Scratches)

It seems that no matter how careful I am, my scanned images always contain a few dust marks. The Dust and Scratches filter in Elements helps to eliminate these annoying spots by blending or blurring the surrounding pixels to cover the defect. The settings you choose for this filter are critical if you are to maintain image sharpness whilst removing small marks. Too much filtering and your image will appear blurred, too little and the marks will remain. See Figure 5.29

To find settings that provide a good balance try adjusting the threshold setting to zero first. Next use the preview box in the filter dialog to highlight

Design components of
the presentation

Plan sequence with
storyboard

List visual elements to be
created

Shoot props

Download and adjust
images

Remove background and
simplify

Place text in the
presentation program

Copy and paste graphic
elements

Resize pictures to fit the
slide

Figure 5.28 (Full captions provided on page 96)

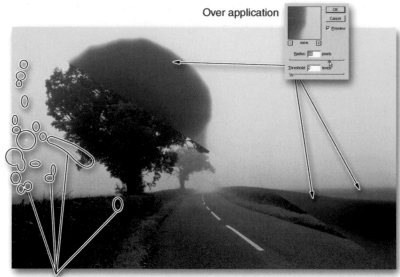

Over application

Dust marks

Figure 5.29 Too much Dust and Scratches filtering can destroy image detail and make the picture fuzzy

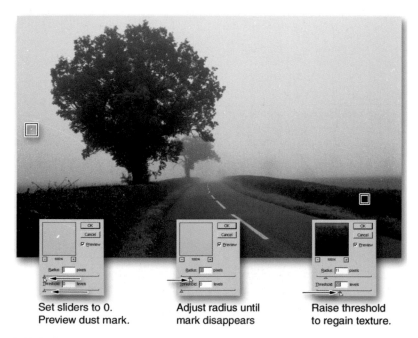

Set sliders to 0.
Preview dust mark.

Adjust radius until
mark disappears

Raise threshold
to regain texture.

Figure 5.30 Follow the three-step process to ensure that you choose the optimal settings for the Dust and Scratches filter

a mark that you want to remove. Use the zoom controls to enlarge the view of the defect. Now drag the Radius slider to the right. Find, and set, the lowest radius value where the mark is removed. Next increase the threshold value gradually until the texture of the image is restored and the defect is still removed. See Figure 5.30.

Feature summary

1 Select Filter>Noise>Dust and Scratches.
2 Move preview area to highlight a mark to be removed.
3 Zoom the preview to enlarge the view of the mark.
4 Ensure that the threshold value is set to zero.
5 Adjust radius slider until the mark disappears.
6 Adjust threshold until texture returns and mark is still not visible.
7 Click OK to finish.

Clone Stamp

In some instances the values needed for the Dust and Scratches filter to erase or disguise picture faults are so high that it makes the whole image too blurry for use. In these cases it is better to use a tool that works with the problem area specifically rather than the whole picture surface.

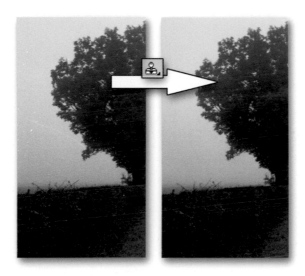

Figure 5.31 The Clone Stamp tool is perfect for retouching the marks that the Dust and Scratches filter cannot erase

The Clone Stamp tool samples an area of the image and then paints with the texture, color and tone of this copy onto another part of the picture. This process makes it a great tool to use for removing scratches or repairing tears or creases in a photograph. Backgrounds can be sampled and then painted over dust or scratch marks, and whole areas of a picture can be rebuilt or reconstructed using the information contained in other parts of the image. See Figure 5.31.

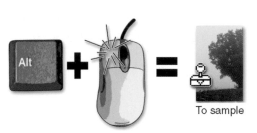

To sample

Figure 5.32 Alt-Click (Windows) or Option-Click (Macintosh) to mark the area to be sampled

Using the Clone Stamp tool is a two-part process. The first step is to select the area that you are going to use as a sample by Alt-Clicking (Windows) or Option-Clicking (Macintosh) the area. See Figure 5.32. Now move the cursor to where you want to paint and click and drag to start the process. See Figure 5.33.

The size and style of the sampled area is based on the current brush and the opacity setting controls the transparency of the painted section.

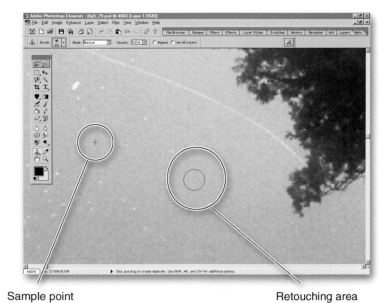

Sample point Retouching area

Figure 5.33 Move the cursor over the mark and click to paint over with the sampled texture

Feature summary

1 Pick the Clone Stamp tool from the toolbox.
2 Adjust the brush size via the brush palette in the options bar.
3 Set the opacity for the painted area.
4 Position the mouse cursor on a part of the image you want to sample and Alt-Click (Windows) or Option-Click (Macintosh) to set.
5 Move the tool to the area of the image you want to use the sample to cover and click-drag to paint. Note: When cloning areas that have defects, keep altering the source area selected so that you do not build recognizable repeats. This way you avoid the very obvious 'herring-bone' patterns associated with multiple repeats of the same area.

Adding texture to an image

At first the idea of making a smooth, evenly graduated image more textured seems to be at odds with the general direction that digital technology has been heading over the last few years. Research scientists and technicians have spent much time and money ensuring that the current crop of cameras, scanners and printers are able to capture and produce images so that they are in effect texture or grainless. The aim has been to disguise the origins of the final print so that the pixels cannot be seen. See Figure 5.34.

Pixelated

Pixel-less or grainless

Figure 5.34 The aim of digital development over the last few years has been to achieve a pixel-less and texture-free Image

Figure 5.35 The grainy image does provide a sense of atmosphere that pixel perfect pictures seem to lack

For me to introduce to you at this stage a few techniques that intentionally add noticeable texture to your image may seem a little strange, but despite the intentions of the manufacturers, a lot of digital image makers do like the atmosphere and mood that a 'grainy' picture conveys. See Figure 5.35. All the techniques use filters to alter the look of the image. Filter changes are permanent so it is always a good idea to keep a copy of the unaltered original file on your hard drive, just in case.

The Noise filter

The Add Noise filter is one of four options contained under the Noise heading in the Filter menu. Using this feature adds extra contrasting pixels to your image to simulate the effect of high-speed film. See Figure 5.36. When the filter is selected, you are presented with a dialog that contains several choices. A small zoomable thumbnail window is provided so that you can check the appearance of the filter settings on your image. There is also the option to preview the results on the greater image by ticking the preview box. The strength of the effect is controlled by the Amount slider and the type of noise can be switched from Uniform, a more even effect, to Gaussian, for a speckled appearance. The Monochromatic option adds pixels that contrast in tone only and not color to the image. See Figure 5.37.

Feature summary

1 Select the Add Noise filter from the Noise section of the Filter menu (Filter>Noise>Add Noise).
2 Adjust thumbnail preview to a view of 100% and tick the Preview option.

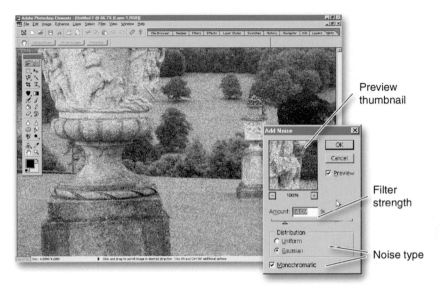

Preview thumbnail

Filter strength

Noise type

Figure 5.36 Use the Add Noise filter for basic texture additions

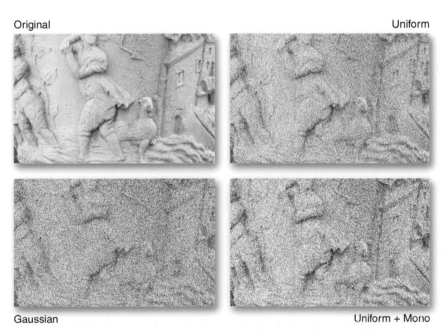

Original

Uniform

Gaussian

Uniform + Mono

Figure 5.37 The Add Noise filter settings control the look of the final texture

3 Select Uniform for an even distribution of new pixels across the image, or pick Gaussian for a more speckled effect.

4 Tick the Monochromatic option to restrict the effect to changes in the tone of pixels rather than color.

5 Adjust the Amount slider to control the strength of the filter checking the results in both the thumbnail and full image previews.

6 Click OK to finish.

The Grain filter

Found under the Texture option in the Filter menu, the Grain filter, at first glance, appears to offer the same style of texture changes as the Add Noise feature, but the extra controls in the dialog give the user the chance to add a range of different texture types to their images. See Figure 5.38. The dialog provides a thumbnail preview of filter changes. The Intensity slider controls the strength of the effect and the contrast control alters the overall appearance of the filtered image. The Grain Type menu provides 10 different choices of the style of texture that will be added to the image. By manipulating these three settings it is possible to create some quite different and stunning texture effects. See Figures 5.39, 5.40 and 5.41.

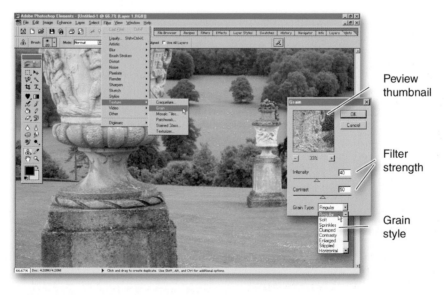

Peview thumbnail

Filter strength

Grain style

Figure 5.38 The Grain filter provides a little more control over the type of texture that is added to your images

Figure 5.39 *The example is textured using the Grain filter with the Horizontal option set*

Figure 5.40 *The example is textured using the Grain filter with the Speckle option set*

Figure 5.41 The example is textured using the Grain filter with the Stippled option set

Feature summary

1 Select the Grain filter from the Texture section of the Filter menu (Filter>Texture>Grain).
2 Adjust thumbnail preview to a view of 100%.
3 Select Grain Type from the menu.
4 Adjust the Intensity slider to control the strength of the filter checking the results in the thumbnail preview.
5 Alter the Contrast slider to change the overall appearance of the image.
6 Click OK to finish.

The Texturizer filter

The Texturizer filter provides a slightly different approach to the process of adding textures to images. With this feature much more of the original image detail is maintained. The image is changed to give the appearance that the picture has been printed onto the surface of the texture. The Scaling and Relief sliders control the strength and visual dominance of the texture, whilst the Light Direction menu alters the highlight and

Preview
thumbnail

Texture
type

Filter
strength

Figure 5.42 The Texturizer filter changes the image so that it appears to have been printed onto a textured surface

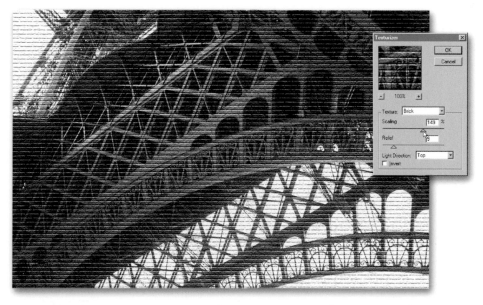

Figure 5.43 The example is textured using the Texturizer filter with the Brick surface selected

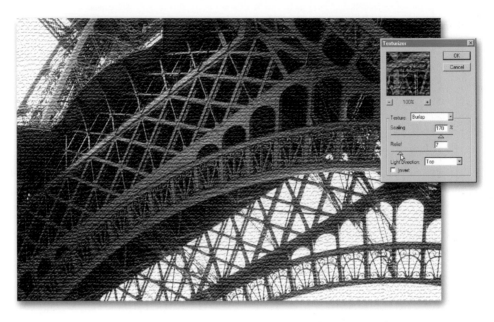

Figure 5.44 The example is textured using the Texturizer filter with the Burlap surface selected

shadow areas. See Figure 5.42. Different surface types are available from the Texture drop-down menu. See Figures 5.43 and 5.44. The feature also contains the option to add your own files and have these used as the texture that is applied by the filter to the image.

Feature summary

1 Select the Texturizer filter from the Texture section of the Filter menu (Filter>Texturizer>Texture).
2 Adjust thumbnail preview to a view of 100%.
3 Select Texture type from the drop-down menu.
4 Move the Scaling slider to change the size of the texture.
5 Adjust the Relief slider to control the dominance of the filter.
6 Select a Light Direction to adjust the highlights and shadow areas of the texture.
7 Tick the Invert box to switch the texture position from 'hills' to 'valleys' or reverse the texture's light and dark tones.
8 Click OK to finish.

Making your own textures

Being able to make your own texture files is the real bonus of the Texturizer filter. This ability gives the user the chance to extend the available surface options by adding customized Elements files that have been designed, or captured, especially for the purpose. Any Elements, or Photoshop, file (.PSD) can be loaded as a new texture via the Load Texture option in the Texture drop-down menu of the Texturizer dialog. Simply locate the file using the browsing window and then adjust the Scaling, Relief and Lighting controls as you would for any of the built-in surface options.

Feature summary

1 Shoot, scan or design a texture image and save as an Elements or Photoshop file (.PSD). See Figure 5.45.
2 Select the Texturizer filter from the Texture options of the Filters menu (Filters>Texture>Texturizer).
3 Pick the Load Texture item from the drop-down list in the Texture menu. See Figure 5.46.
4 Browse folders and files to locate texture file.
5 Click file name and then open to select.
6 Once back at the Texturizer dialog treat like any other surface option. See Figure 5.47.

Figure 5.45 Shoot your own texture and save the image as an Elements or .PSD file

Load
texture
file

Figure 5.46 Load the new texture into the filter

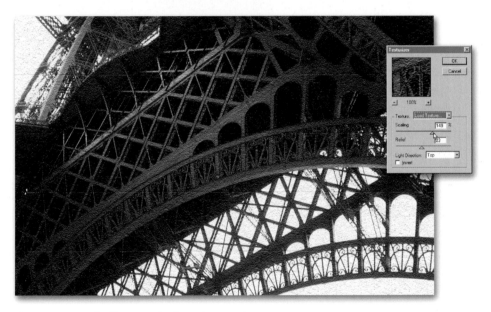

Figure 5.47 Apply the new texture to your image

Real life digital imaging: restoration of a family heirloom

Stored away in the in the lofts of many homes is a collection of family history documents. Usually contained in boxes, or old suitcases, they are a mixture of photographs and letters. One of the first tasks that a family member with a new interest in digital imaging inherits is the restoration of some of these heirlooms back to their former glory. Suffering from a mixture of scratches, stains and fading these images can be improved and repaired using a combination of the techniques introduced in this and the preceding chapter. See Figure 5.48.

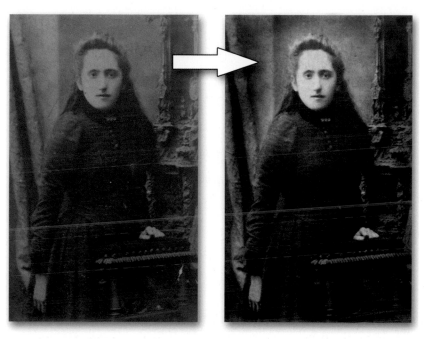

Figure 5.48 Digital retouching techniques can be used to restore all those family heirlooms to their former glory

Web link: Practice your restoration skills on the example image available from the book's website.

Captions to Figure 5.49 (see page 112)

1 Open up the scanner plug-in either from within Elements or via the Acquire option in the Quick Start screen

2 Capturing the photograph to be restored is a critical part of the process. Make sure that the scanner's contrast and brightness settings are adjusted to capture all the highlight and shadow details contained in the original

3 With the image imported into Elements rotate and crop the image using the Straighten and Crop Image selection from the Rotate section of the Image menu. For manual control you can use the Crop tool from the toolbox

4 Use the finer tone control of Levels (Enhance>Brightness/Contrast>Levels) to peg the white and black points in the image

5 Adjust the midtone value in levels to darken or lighten middle value tones in the image

6 Use the Dust and Scratches filter (Filter>Noise>Dust and Scratches) to eliminate some of the marks on the image surface. For more difficult areas or those sections that need reconstruction use the Stamp tool to copy and paste new tones and textures

7 Darken or lighten selected areas of the picture using the Dodging or Burning tools

8 Sharpen the image by using the Unsharp Mask filter (Filter>Sharpen>Unsharp Mask). Ensure that the preview thumbnail is set to 100% to gauge the strength of the filter effect

9 Tone the final image using the Colorize option from within the Hue/Saturation feature (Enhance>Color>Hue/Saturation)

Place print in scanner and open driver

Adjust scanner to capture all tones

Straighten and crop image

Adjust tones using levels

Adjust midtones

Remove dust and scratches

Use the Dodge and Burn tools

Sharpen the image

Tone the picture

Figure 5.49 (Full captions provided on page 111)

6 Using Selections and Layers

For those users who are a little familiar with both Selections and Layers it might seem a bit strange to group these features together, but to my mind they both deal with a similar idea – isolating specific sections of an image to make them easier to manipulate. They also represent two Elements features that are central to a lot of advanced manipulation and enhancement techniques.

Selection basics

Until now we have assumed that any changes being made to an image will be applied to the whole of the picture, but before too long it will become obvious that there are many imaging scenarios that would benefit from being able to restrict alterations to a specific part of an image. For this reason most image-editing packages contain several features that allow the user to isolate small sections of an image that can then be altered independently of the rest of the image.

When a selection is made the edges of the isolated area are indicated by a flashing dotted line, which is sometimes referred to as the 'marching ants'. See Figure 6.1. When a selection is active any changes made to the image will be restricted to the isolated area. See Figure 6.2. To resume full editing mode the area has to be Deselected (Select>Deselect).

The selection features contained in Elements can be divided into two groups:

- *Drawing selection tools*, or those that are based on selecting pixels by drawing a line around the part of the image to be isolated, and
- *Color selection tools*, or those features that distinguish between image parts based on the color or tone of the pixels.

Figure 6.1 The edges of an active selection are indicated using a flashing dotted line or 'marching ants'

Figure 6.2 Image alterations made when a selection is active are restricted to the area of the selection

Drawing Selection tools (see Figures 6.3 and 6.4)

The tools contained in the Marquee and Lasso tool sets are used to draw around the pixels in an image. By clicking and dragging the Rectangular or Elliptical Marquees, it is possible to draw rectangle- and oval-shaped selections. Holding down the Shift key whilst using these tools will restrict the selection to square or circular shapes, whilst using the Alt (Windows) or Options (Mac) keys will draw the selections from their centers. The Marquee tools are great for isolating objects in your images that are regular in shape, but for less conventional shapes, you will need to use one of the Lasso tools.

The normal Lasso tool works like a pencil allowing the user to draw freehand shapes for selections. In contrast, the Polygonal Lasso tool draws straight edge lines between mouse-click points. Either of these features can be used to outline and select irregular-shaped image parts. See Figure 6.5.

A third tool, the Magnetic Lasso, helps with the drawing process by aligning the outline with the edge of objects automatically. See Figure 6.6. It uses contrast in color and tone as a basis for determining the edge of an object. The accuracy of the 'magnetic' features of this tool is

Figure 6.3 The Elliptical and Rectangular Marquee tools are used for making selections in these shapes

adobe photoshop elements

Constrained Unconstrained

Figure 6.4 Holding down the Shift key when using the marquee tools will constrain the selection to either a square or a circle

Figure 6.5 The Lasso, Polygonal Lasso and Magnetic Lasso tools are used for selecting irregularly shaped image parts

determined by three settings in the tool's options bar. See Figure 6.7. Edge Contrast is the value that a pixel has to differ from its neighbor to be considered an edge, Width is the number of pixels either side of the pointer that are sampled in the edge determination process and Frequency is the distance between fastening points in the outline. For most tasks, the Magnetic Lasso is a quick way to obtain accurate selections, so it is good practice to try this tool first when you want to isolate specific image parts.

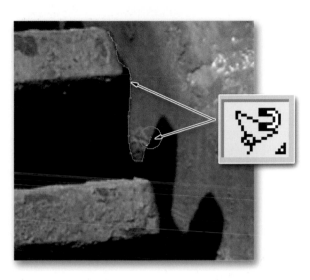

Figure 6.6 The Magnetic Lasso snaps to the edge of objects

Figure 6.7 The settings in the Magnetic Lasso's options bar alters how the tool snaps to the outline of particular image parts

Feature summary

Rectangular and Elliptical Marquee tools

1 After selecting the tool, click and drag to draw a marquee on the image surface.
2 Hold down Shift key whilst drawing to restrict the drawn shape to either a square or a circle.
3 Hold down the Alt (Windows) or Option (Mac) to draw the shape from its center.

Lasso tool

1 After selecting the tool, click and drag to draw the selection area by freehand.
2 Release the mouse button to join the beginning and end points and close the outline.

adobe photoshop elements

Polygonal Lasso tool

1 After selecting the tool, click and release mouse button to mark the first fastening point.
2 To draw a straight line, move the mouse and click again to mark second point.
3 To draw a freehand line, hold down the Alt (Windows) or Option (Mac) keys and click and drag the mouse.
4 To close the outline either move cursor over the first point and click or double click.

Magnetic Lasso tool

1 After selecting the tool, click and release the mouse button to mark the first fastening point.
2 Trace the outline of the object with the mouse pointer. Extra fastening points will be added to the edge of the object automatically.
3 If the tool doesn't snap to the edge automatically, click the mouse button to add a fastening point manually.
4 Adjust settings in the options bar to vary the tool's magnetic function.
5 To close the outline, either double click or drag the pointer over the first fastening point.

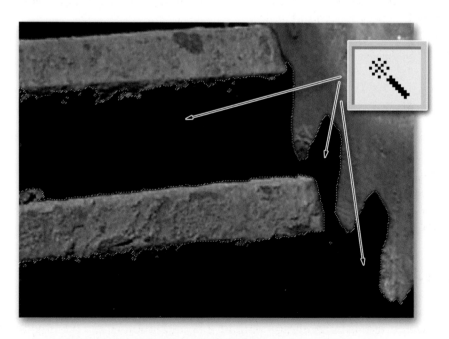

Figure 6.8 The Magic Wand selects pixels of similar color and tone

Color Selection tools

Unlike the Lasso and Marquee tools the Magic Wand makes selections based on color and tone. See Figure 6.8. When the user clicks on an image with the Magic Wand tool Elements searches the picture for pixels that have a similar color and tone. With large images this process can take a little time but the end result is a selection of all similar pixels across the whole picture. How identical a pixel has to be to the original is determined by the Tolerance value in the options bar. See Figure 6.9. The higher the value, the less alike the two pixels need to be, whereas a lower setting will require a more exact match before a pixel is added to the selection. Turning

Figure 6.9 The Tolerance setting determines how alike pixels need to be before they are included in the selection

on the Contiguous option will only include the pixels that are similar and are adjacent to the original pixel in the selection. See Figure 6.10.

Feature summary

1 With the Magic Wand tool active click onto the part of the image that you want to select.
2 Modify the Tolerance of the selection by altering this setting in the options bar.
3 Constrain the selection to adjacent pixels only, by checking the Contiguous option.

Modifying Selections

With some complex images no one selection technique will be able to isolate all the pixels required, instead a combination of tools is needed to make the final outline. To aid with this Adobe has included several

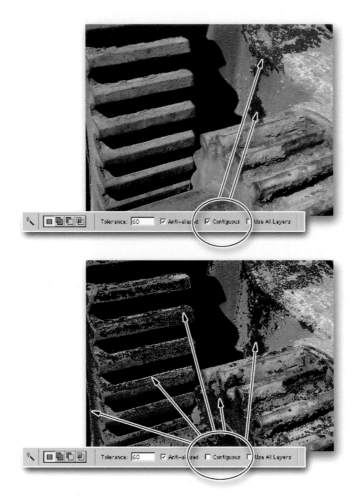

Figure 6.10 The Contiguous option restricts the selection to those pixels adjacent to where the tool was first clicked on the image surface

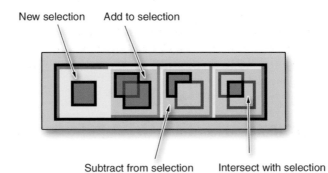

Figure 6.11 The choices in the selection tools options bar determine how the new selection interacts with the existing one

selection possibilities in the options bar of all tools. See Figure 6.11. With these options, it is possible to 'add to', or 'subtract from', an existing selection or even use the 'intersection' of two separate selections as the basis for a third. Simply choose a different Selection option when using a new tool. For those users who prefer to use keyboard shortcuts, holding down the Shift key whilst using a selection tool will add to an existing outline whereas using the Alt (Windows) or Option (Mac) keys will subtract. See Figures 6.12 and 6.13.

Figure 6.12 Hold down the Shift key whilst drawing a selection to add to an existing outline	*Figure 6.13 Hold down the Alt (Windows) or Option (Mac) key whilst drawing a selection to subtract from an existing outline*

All of this may seem a little complex to start with, but it is important to persevere, as good selecting skills are critical for a lot of advanced editing techniques and besides, after some practice, making multi-tool complex selections will become second nature to you.

Feature summary

1 Add to a selection by either holding down the Shift key whilst using another selection tool or by clicking the 'Add to selection' button in the options bar.
2 Subtract from a selection by either holding down the Alt (Windows) or Option (Mac) keys whilst using another selection tool or by clicking the 'Subtract from selection' button in the options bar.
3 Use the intersection of a new and existing selection to form a third outline by clicking the 'Intersect with selection' button in the options bar before making a new selection.

Selections in action: advanced dodging and burning

Previously we have used the Dodging and Burning tools to adjust the tones in our images. Now, using carefully made selections, it is possible

to darken, or lighten, whole areas of your pictures. To start, use the Lasso tool to select a portion of your image.

Next open the Levels dialog (Enhance>Brightness/Contrast>Levels). Move the midtone input slider to the left to lighten the selected tones, or to the right to darken them. Notice that the levels changes have successfully dodged, or burned, the image. There is one problem with the

Sharp edge selection

Feathered edge selection

Figure 6.14 Changes made with a sharp edged selection are more obvious than when they are applied to a selection with a feathered edge

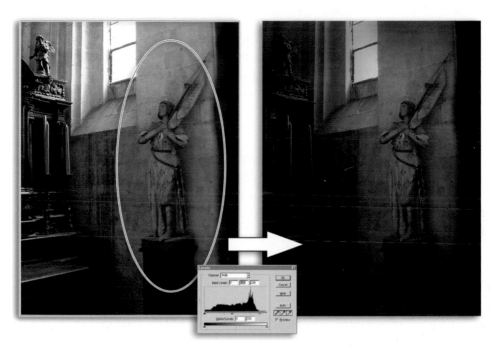

Figure 6.15 Using a feathered edge selection it is possible to easily lighten or darken whole areas of an image

Figure 6.16 Shallow depth of field effects are the current picture fashion for food photographers

results though; the changes are noticeable because of the sharp edge of the selection. A little modification is needed. Undo (Edit>Undo) the levels adjustment and then, with the selection still active, apply a Feather (Select>Feather) to its edge. This command will soften the edge of the selection and make the change between areas that have been altered and sections that have not more gradual. See Figures 6.14 and 6.15.

Before digital depth of field

After digital depth of field

Figure 6.17 You can create a digital look-a-like version by combining a feather selection and the effects of the Gaussian Blur filter

Selections in action: artificial depth of field

These days it is difficult to open the color magazine from a weekend paper without being confronted by a shallow depth of field picture. It seems that this photographic technique is very popular with food photographers in particular; the majority of the image is blurry, save for a single small and sharply focused portion. See Figures 6.16 and 6.17.

A similar effect can be created digitally using simple selection techniques. Again start the process by making a feathered selection of the part of your image that you want to remain sharp. Next, invert (Select>Inverse) the selection so that the rest of the image is now isolated. Using the Gaussian Blur filter (Filter>Blur>Gaussian Blur) change the sharpness of the selection until the desired effect is achieved.

Layers and their origins

The first image-editing programs used a flat file format. See Figure 6.18. All the information for the file was contained in a single plane and all changes made to the image were permanently and irreversibly stored in this file. It didn't take users and software manufacturers long to realize that a more efficient and less frustrating way to work was to build an image from a series of picture parts each contained on its own layer. The

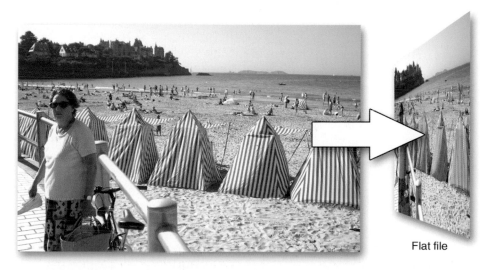

Flat file

Figure 6.18 A flat file contains all the image information in a single plane

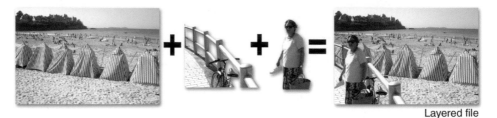

Layered file

Figure 6.19 Multilayered image files are used by most editing programs as a way to separate different picture components whilst keeping them available for editing and enhancement purposes

concept wasn't entirely new; the cell animation industry has used the idea for years. Each character and prop was painted onto a transparent plastic sheet, which was then layered together over a solid background. When seen from above the components and the background appeared to be a single image.

Adobe in Photoshop and Photoshop Elements has based its layers system on this idea. See Figure 6.19. When an image is first created and opened in the editing package it becomes the background by default. Any other images that are copied and pasted onto the image, or text that is added to the picture, become a layer that sits on top of this background. Just as with the animation version the uppermost layer is viewed first and the other layers and background then show through the transparent areas of each other layer.

The Layers palette

Figure 6.20 The Layers palette in Elements shows the content and position of each layer within the stack

Undoubtedly this whole idea might seem a little confusing to the new user, but the benefits of a system that allows picture parts to be moved and adjusted independently far outweigh the time it will take to understand the concept. To help visualize the set-up, Elements contains a specialist Layers palette that shows each of the individual layers, their position in the layer stack and a small thumbnail of their contents. See Figure 6.20.

A transparent area represented by a chequerboard gray and white pattern surrounds any image parts that are smaller than the background. The eye, sitting to the left of

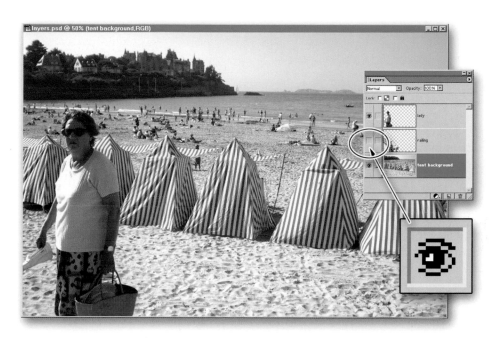

Figure 6.21 Clicking the Eye icon removes that layer from view in the image

the thumbnail, shows that the layer is visible. Clicking on this icon will make the eye disappear and remove the image part from the whole picture. Only one layer in the stack can be manipulated at a time and for this reason it is called the 'Working Layer'. See Figure 6.21. This layer will be colored differently than the others and will show a brush icon between the eye and the thumbnail. Clicking on a different layer in the area to the right of the thumbnail will make this layer the new working layer. See Figure 6.22.

When the full image is saved as an Elements file in PSD format, all the individual layers are maintained and can be manipulated individually when the picture is opened next. This is not true if the image is saved in other formats like TIFF or JPEG. Here the information contained in each layer is merged together at the time of saving to form one flat file.

Active layer

Figure 6.22 The active or working layer is a different color to the others in the stack

Layer types

Image layers

Several different types of layers can be added to an Elements image; of these the most simple, and probably obvious, is the image layer. When an image part is copied and pasted it automatically makes a new layer. This is true whether the picture part came from the original image or from another already opened. When this new layer is selected as the working layer it can be moved around the image surface using the Move tool. The contents can also be changed in size and shape using one of the four options found in the Transform menu (Image>Transform>Free Transform or Skew or Distort or Perspective). See Figure 6.23. These features allow you to manipulate the layer to fit the other components of the image.

The Background layer is a special image layer. Its dimensions define the image size. It is also locked by default meaning that it cannot be moved. You can restrict the movement of other key layers by clicking the Lock icon in the top part of the layers palette. Ticking the Transparency option located next to the Lock icon will not allow any changes made to the layer impinge on the transparent area.

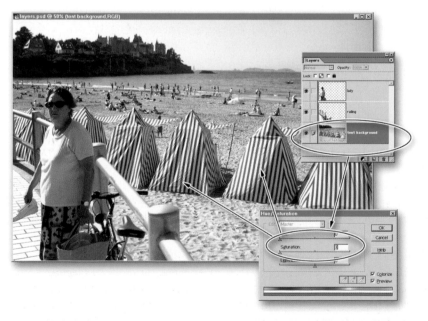

Figure 6.23 Individual image layers can be manipulated independently of other layers in the stack

Type layers

Type layers do not show a thumbnail of their contents in the Layers palette. See Figure 6.24. A large 'T' is positioned in its place and the first few words of the text are used as the layer's name. Unlike other packages Elements' type layers remain editable even after they have been saved, provided that the file has been saved in the PSD format.

Figure 6.24 Elements uses editable type layers for any text that is added to images

Adjustment layers

Adobe added adjustment layers to Photoshop as a way for users to change the look of images whilst retaining the integrity of the image file. Familiar image-change features, such as Levels and Hue/Saturation, are available as adjustment layers, and depending on where they are placed in the layer stack, will alter either part, or all of the image. See Figure 6.25.

Adjusting your images using these types of layers is a good way of ensuring that the basic picture is not changed in anyway. The other advantage is that the settings in the adjustment layers can be edited and changed at a later date, even after the file has been saved. Users can access the original settings used to make the alteration by double clicking the Dialog icon on the left-hand side of the Adjustment layer.

Figure 6.25 Adjustment layers alter the look of all layers that are positioned beneath them in the stack, unless they are grouped with the layer beneath by holding the Option/Alt key down and clicking the dividing line between each in the Layers palette

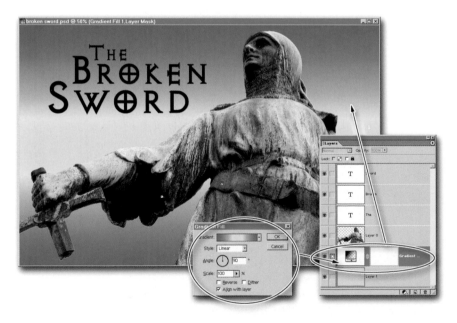

Figure 6.26 Fill layers are a quick way to add a gradient or solid color background to an image

Fill layers

Users can also apply a Solid Color, Gradient or Pattern to an image as a separate layer. These three selections are available as a separate item (Layer>New Fill Layer) under the Layer menu or grouped with the Adjustment layer options via the quick button at the bottom of the Layers palette. See Figure 6.26.

Layer transparency

Until this point we have assumed that the contents of each layer were solid. When it is placed on top, and in front, of the contents of another layer, it obscures the underneath objects completely. And for most imaging scenarios this is exactly the way that we would expect the layers to perform, but occasionally it is desirable to allow some of the detail, color and texture of what is beneath to show through. To achieve this effect the 'transparency' of each layer can be interactively adjusted via the Opacity slider control in the top right-hand corner of the palette. See Figure 6.27. Keep in mind that making the selected layer less opaque will result in it being more transparent.

Figure 6.27 Altering the opacity of a layer allows the color, texture and tone of the image beneath to show through

Layer blend modes

The layer blending modes extend the possibilities of how two layers interact. See Figure 6.28. Seventeen different mode options are available in the drop-down menu to the left of the Opacity slider in the Layers palette. For ordinary use the mode is kept on the Normal mode, but a host of special effects can be achieved if a different method of interaction, or mode, is selected.

Figure 6.28 Layer blending modes control the way that two separate layers interact

The mode options are the same ones available for use with tools like the Paintbrush and Pencil tools, and some advanced editing or enhancement techniques are based on their use. Experimenting with different modes will help you understand how they affect the combining of layers and will also help you to determine the best occasions to use this feature.

Layer Styles

Early on in the digital imaging revolution users started to place visual effects like drop shadows or glowing edges on parts of their pictures. A large part of any class teaching earlier versions of Photoshop was

designated to learning the many steps needed to create these effects. With the release of packages like Elements, these types of effects have become built-in features of the program. Now it is possible to apply something like a drop shadow to the contents of a layer with the click of a single button. See Figure 6.29.

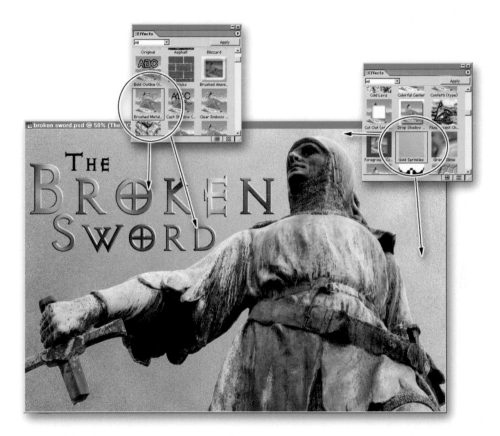

Figure 6.29 You can add a variety of effects to the content of your layers with the Layer Styles feature

Adobe has grouped all these layer effects under a single palette called Layer Styles. As with a lot of features in the program, a thumbnail version of each style provides a quick reference to the results of applying the effect. To add the style to a selected layer simply click on the thumbnail. Multiple styles can be applied to the one layer and the settings used to create the effect can be edited by double clicking the '*f*' icon on the selected layer in the palette.

adobe photoshop elements

Real life digital imaging: the restaurant menu

Updating a restaurant menu to keep track with the seasonal availability of ingredients can be a long-winded and costly affair. Each time a dish is replaced the menu has to be redesigned and printed to account for the changes. However, if the menu is created digitally using a package like Elements and the different dishes and their descriptions stored in different layers, then changing the food list at short notice can be as simple as switching off one layer and turning

Figure 6.30 A multilayered menu document allows changes of content to be made easily and quickly

on another. The new look menu can then be printed and displayed. The selection tools and layer techniques we looked at in this chapter are central to the production of this quick change menu. See Figure 6.30.

Web link: Try making a version of this menu yourself with the downloadable image and text components from the book's website.

Captions to Figure 6.31 (see page 136)

1 The general design for the menu was sketched roughly on paper taking into account that the layout would not change, but particular menu items might be added or taken away depending on ingredient availability
2 The image content was then shot making sure that each component had similar lighting and angle of view. These settings were noted down so they could be repeated later for new dishes
3 A base Elements document was then created with all the static elements compiled on the background layer
4 The pictures were then imported as separate documents into Elements
5 Each image was adjusted and cut from its background. The image parts were then copied and pasted as new layers into the base menu file
6 The description and pricing for each dish were then added as a text layer. The text layer and its associated image layer were then linked so that they could be moved together
7 With the layout complete the menu was printed and was ready for display
8 With changing availability of ingredients new dishes were added to the menu. Older items were kept in the stack but were removed from view by clicking their Eye icons
9 With the changes complete the new version of the menu was printed and displayed

Make a preliminary design

Shoot the various design parts

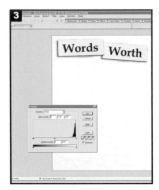

Create the base document

Import the design parts

Remove background and adjust each image

Add descriptive text

Print completed menu

Make changes to images and text

Print new version of menu

Figure 6.31 (Full captions provided on page 135)

7 Combining Text with Your Images

Digital imaging has blurred the boundaries between a lot of traditional industries. No longer does the image maker's job stop the moment the illustration or photograph hits the art director's desk. With the increased abilities of software like Photoshop Elements has come the expectation that not only are you able to create the pictures needed for the job but you will also be able to perform other functions like adding text. See Figure 7.1.

Figure 7.1 Current image-editing programs like Elements have a range of sophisticated text features built in

adobe photoshop elements

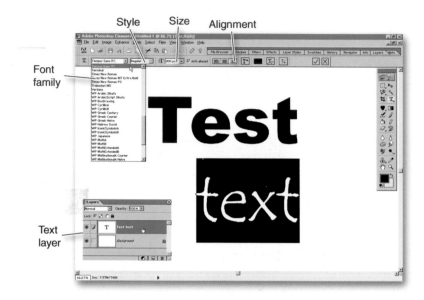

Style Size Alignment

Font
family

Text
layer

Figure 7.2 In Elements text can be entered and change directly on the image surface

Combining text and images is usually the job of a graphic designer or printer but the simple text functions that are now included in most desktop imaging programs mean that more and more people are trying their hand at adding type to pictures. Elements provides the ability to input type directly onto the canvas rather than via a type dialog. This means that you can see and adjust your text to fit and suit the image beneath. Changes of size, shape and style can be made at any stage by selecting the existing text and applying the changes via the options bar. As the type is saved as a special type layer it remains editable even when the file is closed so long as it is saved and reopened in the Elements PSD format. See Figure 7.2.

Creating simple type

Elements provides two Type tools – one is used for entering text that runs horizontally across the canvas, the other is for entering vertical type. See Figure 7.3. To place text onto your picture select the Type tool from the toolbox. Next click onto the canvas in the area where you want the text to appear. Don't be too concerned if the letters are not

Figure 7.3 Two text options are available via the Type tool selection in the toolbox

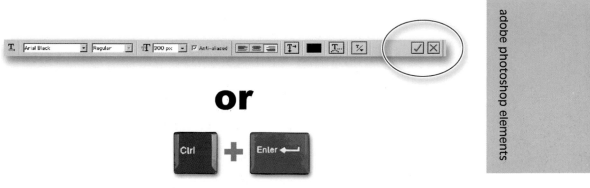

Figure 7.4 Any text entered must be 'committed' to a type layer before other tools or menu choices can be used

positioned exactly as the layer and text can be moved later. Once you have finished entering text you need to commit the type to a layer. Until this is done you will be unable to access most other Elements functions. To exit the text editor, either click the 'tick' button in the options bar or press the Control+Enter keys in Windows or Command+Return for a Macintosh system. See Figure 7.4.

Basic text changes

All the usual text changes available to word processor users are contained in Elements. It is possible to alter the size, style, color and font of your type using the settings in the options bar. See Figure 7.5. You can

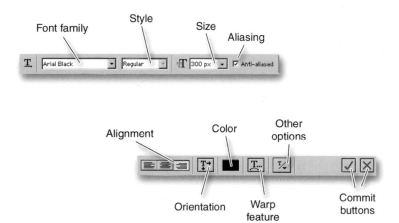

Figure 7.5 The text options bar contains a number of settings for altering the style, font and size of the type entered

Figure 7.6 Use the Move tool to arrange a type layer

either make the selections before you input your text or later by highlighting (clicking and dragging the mouse across the text) the portion of type that you want to change. In addition to these adjustments you can also alter the justification or alignment of a line or paragraph of type. After selecting the type to be aligned click one of the justification buttons on the options bar. Your text will realign automatically on screen.

After making a few changes you may wish to alter the position of the text, simply click and drag outside of the type area to move it around. If you have already committed the changes to a text layer then select the Move tool from the toolbox, making sure that the text layer is selected, then click and drag to move the whole layer. See Figure 7.6.

Feature summary

1 Choose the Type tool from the toolbox. To change between horizontal and vertical type click and hold on the tool to reveal the hidden option.
2 Click on the picture surface to position the start of the text.

3 Make changes to font type, size, style, justification and color by altering the settings in the options bar.

4 Enter your text using the keyboard or by pasting sections (Edit>Paste) from a copied word processing document.

5 Click and drag to move the text over the image background.

6 Commit entered text or changes to a type layer by clicking 'tick' in options bar or by pressing Control+Enter (Windows) or Command +Return (Mac) keys.

Reducing the 'jaggies'

One of the drawbacks of using a system that is based on pixels to draw sharp edged letter shapes is that circles and curves are made up of a

Figure 7.7 The anti-aliasing setting helps smooth out 'jagged' text

series of pixel steps. Anti-aliasing is a system where the effects of these 'jaggies' are made less noticeable by partially filling in the edge pixels. This technique produces smoother looking type overall and should be used in all print circumstances and web applications. See Figure 7.7. The only exception being where file size is critical, as anti-aliased web text creates larger files than the standard text equivalent. Anti-aliasing can be turned on and off by checking the box in the options bar.

Figure 7.8 The Warp feature can be used to twist and squeeze heading text

Feature summary

1 Turn anti-aliasing on by checking the box in the options bar or by selecting Layer>Type>Anti-Alias On.
2 Turn anti-aliasing off by unchecking the box in the options bar or by selecting Layer>Type>Anti-Alias Off.

Warping type

One of the special features of the Elements type system is the 'Warping' feature. This tool forces text to distort to one of a range of shapes. An individual word, or even whole sentences, can be made to curve, bulge or even simulate the effect of a fish-eye lens. See Figure 7.8. The strength and style of the effect can be controlled by manipulating the bend and horizontal and vertical distortion sliders. This feature is particularly useful when creating graphic headings for posters or web pages. See Figure 7.9.

Feature summary

1 Choose a completed type layer.
2 Select Layer>Type>Warp Text or pick the Type tool from the toolbox and click the Warp button in the options bar.

Figure 7.9 Warp styles can be altered using the settings in the dialog

3 Choose the warp style from the drop-down menu.
4 Adjust the bend, horizontal and vertical distortion sliders.
5 Click OK to finish.

Applying styles to type layers

Elements' Layer Styles can be applied very effectively to type layers and provide a quick and easy way to enhance the look of your text. Everything from a simple drop shadow to complex surface and color treatments can

| Drop Shadow | Inner Ridge Bevel | Wood Grain | Pink Glass | Purple Neon |

| Waves | Brushed Metal | Molten Gold | Cactus | Chrome Fat |

Figure 7.10 *The look of text can be changed with a single click using Layer Styles*

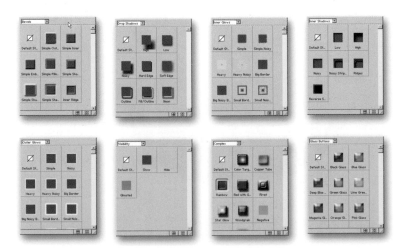

Figure 7.11 *Eight different preset style groups are available under the one menu*

be applied using this single click feature. See Figure 7.10. A collection of included styles can be found under the Layer Styles tab in the Palette Well or you can view the dialog by selecting the Show Layer Styles option from the Window menu. Eight different style groups are available from the drop-down list and small example images of each style are provided as a preview of the effect. See Figure 7.11.

Figure 7.12 Make sure the type layer is selected before applying a layer style

Figure 7.13 Click the thumbnail of the style you wish to apply

Click to
edit style

Style
settings

Figure 7.14 Double click the 'f' at the left-hand side of the type layer to adjust the style settings

To apply a style to a section of type make sure that the text layer is currently active. Do this by checking that the layer is highlighted in the Layers palette. See Figure 7.12. Next open and view the Layer Styles group you wish to use. Click on the thumbnail of the style you want to apply to the text. The changes will be immediately reflected in your image. See Figure 7.13. Multiple styles can be applied to a single layer and unwanted effects can be removed by using the Step Backward button in the shortcuts bar or the Undo command (Edit>Undo Apply Style).

The settings of individual styles can be edited by double clicking on the 'f' icon in the text layer and adjusting one or more of the style settings. See Figure 7.14.

Feature summary

1 Ensure that the text layer is selected.
2 View the Layer Styles palette by clicking its tab in the Palette Well or by selecting Show Layer Styles from the Window menu.
3 Choose the group and style to apply to your text from the drop-down list and thumbnails.
4 Edit style settings by double clicking the 'f' symbol in the text layer.
5 Remove effects by selecting Edit>Undo Layer Styles.

Real life digital imaging: the newspaper advertisement

Advertising in the local newspaper is a good way to attract new custom to small businesses, but often the task of putting together a design can seem to be a little overwhelming. Using the text features in Elements and a few imaging tricks you can produce a simple but effective advertisement, which can be supplied to the paper's classifieds department on disk for inclusion in the next edition. See Figure 7.15.

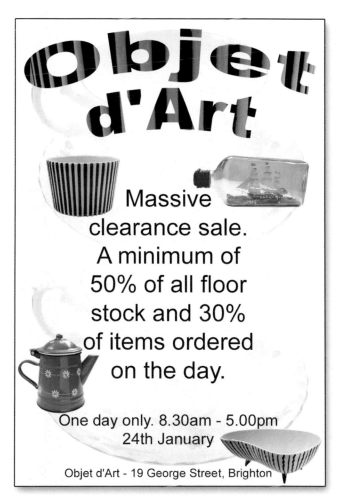

Figure 7.15 Putting together your own advertisement for the local paper combines text and image manipulation skills

Web link: Make your own version of this advertisement using the example images from the book's website.

Captions to Figure 7.16 (see page 149)

1 Find out from your local newspaper's advertising section the exact size and resolution that you need to submit to them. These details will usually be supplied in terms of centimeter or inch dimensions together with a figure for resolution in dots per inch or dpi. For our example we will construct an advertisement that is 12 × 8 cm (h × w) at 300 dpi

2 Next photograph some images that represent your business or the products that you sell. At this stage it is best to shoot a range of different photographs so that you have a few to choose from. Keep in mind when photographing that the advertisement is in a vertical or portrait format and that horizontal images might need to be cropped to fill the space

3 At the same time as shooting, use a word processor to organize and input the text that will be included in the advertisement. At this stage keep the typeface and style simple, as enhancements will me made in Elements

4 Open Elements and select the New option from the Quick Start screen. Input the size and resolution values directly into the New Image dialog

5 Open and select one of the images that you have photographed using the Select All command from the Select menu. Copy (Edit>Copy) and Paste (Edit>Paste) the picture into the advertisement document. With the new layer selected adjust its size using the Image>Transform>Free Transform command

6 Using the Marquee tool make a rectangular selection in the middle section of the image. Feather the selection by 20 pixels (Selection>Feather) and then open the levels dialog (Enhance>Brightness Contrast>Levels). Move the black output slider to the right to lighten the selection

7 Switch to the word processing package and highlight and copy the advertisement text. Switch back to Elements and with the text tool selected click onto the canvas in the lightened area. Paste the copied text here. End of line breaks can be added by inserting the cursor in the correct position and hitting the return or enter key

8 To add a bold heading, insert another text cursor and type directly onto the canvas altering the size and font to suit. Use the Warp and Layer Styles features to make the type stand out from the background

9 Finally to add some more interest to the heading open a second image from those photographed earlier. Select and copy the picture. Switch back to the advertisement and paste the picture onto a layer directly above the heading text. Next insert this new image into the heading text by selecting Group With Previous from the Layer menu

Establish advertisement size

Shoot objects to be included

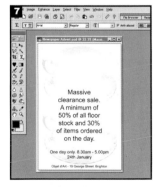

Word process text

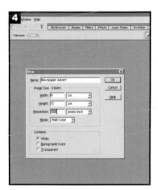

Make a correctly sized Elements document

Copy and paste graphic parts

Adjust the brightness of a feathered selection

Copy and paste text

Adjust text characteristics

Add picture texture to heading text

Figure 7.16 (Full captions provided on page 148)

8 Using Elements' Painting and Drawing Tools

At some point during your imaging life you will need to create an image from scratch. Until now we have concentrated on editing, adjusting and enhancing images that have been generated using either a camera or scanner, now we will look at how to use Elements' painting and drawing tools to create something entirely new.

Although the names are the same the tools used by the traditional artists to paint and draw are quite different from their digital namesakes. The painting tools (the Paint Brush, Pencil, Eraser, Paint Bucket and Airbrush) in Elements are pixel based. That is, when they are dragged across the image they change the pixels to the color and texture selected for the tool. The drawing tools (the Shape tools) in contrast are vector or line based. The objects drawn with these tools are defined mathematically as a specific shape, color and size. They exist independently of the pixel grid that makes up your image. See Figure 8.1.

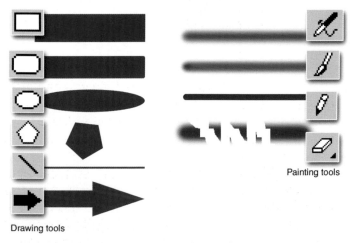

Painting tools

Drawing tools

Figure 8.1 Drawing and painting tools are used to add non-photographed information to your images

Painting tools

The three main painting tools all apply color to an image in slightly different ways.

The *Paint Brush* lays down color in a similar fashion to a traditional brush. The size and shape of the brush can be selected from the list in the Brush palette in the options bar. Clicking the thumbnail of the currently selected brush will allow you to edit and save new settings. Alternatively completely new brushes can be added to the palette by selecting the side arrow in the Brush palette and choosing the New Brush option. Adjust the settings in the dialog to suit and then click OK to finish. See Figure 8.2.

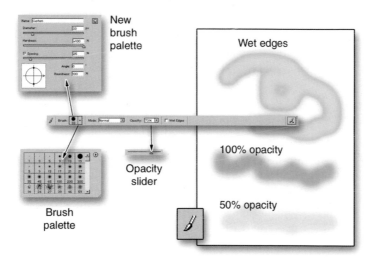

New brush palette

Wet edges

Opacity slider

Brush palette

100% opacity

50% opacity

Figure 8.2 The paint brush size and type can be changed via the settings in the options bar

In addition to the size and shape of the brush tip you can also alter how the paint brush behaves. Setting the Opacity will change the degree that the image beneath the brush stroke shows through the paint. Selecting Wet Edges will add extra paint to the edges of the stroke in a manner similar to water color paint.

The *Airbrush* sprays the paint color over the surface of the image. Although the size and style of the spray is determined by the selected brush (in the options bar) the edge of the area painted with this tool is a lot softer than the equivalent paint brush. Holding the mouse button down in one spot will build up the color in much the same way as paint from a spray can. See Figure 8.3.

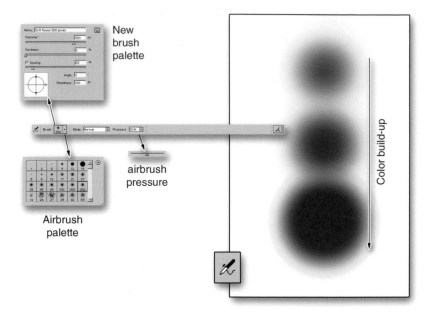

New
brush
palette

airbrush
pressure

Color build-up

Airbrush
palette

Figure 8.3 The airbrush sprays the color onto the canvas. The paint continues to build up as long as you keep the mouse button pressed

The *Pencil* differs from the other tools in that it paints hard edged freehand lines. The thickness of these lines is dependent on the selected brush size. Don't confuse the Pencil with the line version of the Shape tool. The Pencil draws with pixels; the line tool defines a beginning and end point to a mathematical pixel-free line that is drawn only at the time that it is printed. See Figure 8.4.

The color of the paint for all tools is based on the foreground color selected in the toolbox. To change this hue you can double click the swatch and select another color from the palette or you can use the eyedropper to sample a color already existing in your image. See Figure 8.5.

Feature summary

1 Pick foreground color.
2 Select the painting tool from the toolbox.
3 Click the down arrow next to the sample brush in the options bar to select brush size and type.
4 Adjust brush opacity.
5 Adjust other options for a particular tool.
6 Drag brush over image surface to paint.

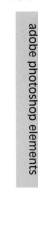

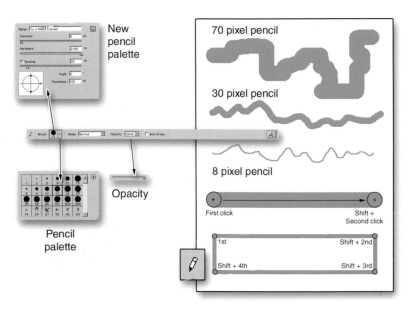

Figure 8.4 The Pencil tool draws hard edged lines

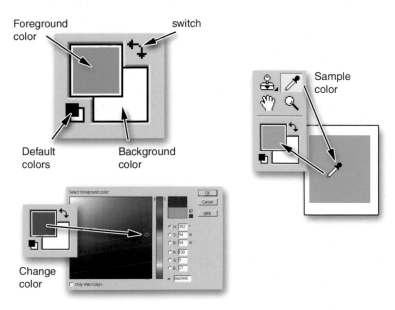

Figure 8.5 All brushes paint with the color that is selected in the foreground/background swatches

The Impressionist Brush tool

In addition to these standard painting options Elements has a specialist Impressionist Brush tool that allows you to repaint existing images with a series of stylized strokes. By adjusting the special paint style, fidelity, size and tolerance options you can create a variety of painterly effects on your images. See Figure 8.6.

Figure 8.6 The Impressionist Brush applies a painterly effect to the picture

Feature summary

1 Pick Impressionist Brush from toolbox.
2 Select brush size and style from options bar.
3 Select the Blend Mode from the list.
4 Select the style.
5 Set the opacity, fidelity, area and spacing options.
6 Drag the brush over the image surface to paint.

Erasing

The Eraser tool changes image pixels as it is dragged over them. If you are working on a background layer then the pixels are erased or changed

Brush
eraser

Block
eraser

■ ⬢ Eraser Tool E
⬢ Background Eraser Tool E
⬢ Magic Eraser Tool E

Figure 8.7 The Eraser tool is used to take away portions of an image

to the background color. In contrast, erasing a normal layer will convert the pixels to transparent, which will let the image show through from beneath. See Figure 8.7.

As with the other painting tools the size and style of the eraser is based on the selected brush. But unlike the others the eraser can take the form of a paint brush, airbrush, pencil or block. Setting the opacity will govern the strength of the erasing action.

Feature summary

1 Pick Eraser tool from the toolbox.
2 Select a brush size and style.
3 Choose the form that the tool will take.
4 Set the opacity.
5 Drag over the image to erase.

Drawing tools

With the Shape tool it is possible to draw lines, rectangles, polygons and ellipses as well as creating your own custom shapes. After selecting the tool and picking the fill color you can draw the shape by clicking and

Hidden shape tools

Figure 8.8 Only one Shape tool is shown in the toolbox, but others can be viewed by clicking and holding the mouse over the small triangle in the bottom right corner of the button

dragging the mouse. Although only one Shape tool is visible in the toolbox at any time, you can select a different option by clicking and holding the mouse button down over the tool icon and then selecting the new tool from the list as it appears. See Figures 8.8 and 8.9.

A new shape layer is opened automatically when you select a tool and draw a new shape. In the Layers palette you will notice that the shape is made up of two parts – the 'fill' and the 'path'. Double clicking the Fill icon will give you the opportunity to change the color. Double clicking the Path icon will allow you to edit the shape's name. See Figure 8.10.

When you create multiple shapes on a single layer you have the opportunity to decide how overlapping areas interact. Two or more different shapes can be added to form a third and the intersection of shapes can be added or subtracted from the image. At first the Shape tool can seem a little confusing but with practice you will be able to build up complex images by gradually adding and subtracting shapes. See Figure 8.11.

Figure 8.9 The Shape tool is used to draw a range of different vector shapes

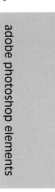

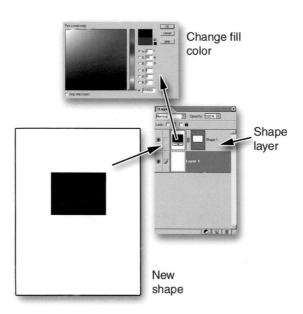

Change fill
color

Shape
layer

New
shape

Figure 8.10 The fill color of a shape can be changed by double clicking the color icon in the shape's layer

Add shapes

New shape

Subtract shapes

Intersect area only

Subtract overlap

Figure 8.11 The way that shapes interact can be customized via buttons on the options bar

Feature summary

1 Pick the Shape tool you require from the toolbox. Click and hold down the mouse button to reveal hidden options.
2 For a new shape pick the Create New Shape Layer option. For adding to an existing shape layer – select the layer and select the shape area option that suits your needs. You can pick from Add, Subtract, Intersect and Exclude.
3 Click on the color swatch to specify the fill color for the shape.
4 Click and drag on the image surface to draw the shape.

Real life digital imaging: producing a stylized business logo

The Eastside Community Support Group is a small network of volunteers who regularly give their time to help settle new migrants in their local area. The group runs many orientation activities that require a great deal of organization and communication with the participants, small businesses and the local authorities.

Presenting a professional face is an important aspect of reassuring all parties that despite the volunteer nature of the network, the group is committed and organized. They found that 'for some people you have to look the part before they give you a chance'. Part of looking the part is having simple but effective stationery. See Figure 8.12.

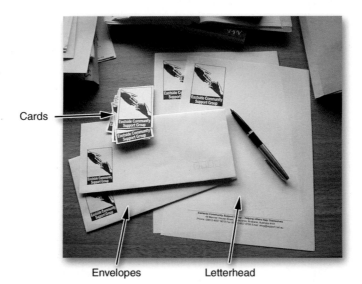

Cards

Envelopes Letterhead

Figure 8.12 A black and white stylized logo is simple and easy to reproduce on a range of stationery items using basic desktop publishing or word processing software

The first task was to produce a logo that was not too complex, represented the group's concerns, was easy to understand and was cheap to reproduce. The 'Helping Hands' image met most of these criteria but needed to be simplified so that it could be reproduced using low cost printers or photocopiers. A basic black and white design seemed to be the solution.

A digital picture of two hands was photographed against a white background and then imported into Elements. The image was then cropped and straightened. The background was erased using the Background Eraser tool. Now that the hands had been isolated from the surrounding detail the Threshold feature was applied to the whole image. This converted all picture tones to either black or white, giving a stark graphic image. The edges of the hands were then stroked and any gray areas were either erased or brushed to black.

To complete the logo the image was cropped again and some inverted text added to a black rectangle at the bottom. The whole image was then selected and stroked with black. The finished logo was then 'Inserted' into word processing software to produce the required stationery.

Web link: Make your own version of this business stationery using the example images from the book's website.

Captions to Figure 8.13 (see page 160)

1 A piece of white card was used as a background for the photograph. This simple step helped when it came to isolating the hands from the background later
2 The digital picture was downloaded from the camera and cropped and straightened in Elements using the Crop tool
3 The Background Eraser tool is designed to eliminate unwanted detail from around a subject. The tool was used here to erase the white background so that only the hands were left
4 The Threshold feature (Image>Adjustments>Threshold) was used to convert the image to just black and white. The slider in the dialog controls the point at which image parts are changed to white or black
5 The background was selected using the Magic Wand tool and the selection was then inverted (Select>Inverse) so that only the hands were selected. The selection was then stroked (Edit>Stroke) with a black six pixel line
6 With the major manipulations complete the Eraser tool was used to clean up any fuzzy or gray areas. The tool was changed from block to paint brush mode to erase smaller details
7 Next the lines were cleaned up and some areas reshaped using the paint brush. To check progress a second view (View>New) of the image was opened. Changes were made on the magnified view and the effects of these changes checked on the full view
8 With the retouching complete, the image was cropped and stroked again. A black rectangle was added to the bottom and the name of the group was laid out in white type

9 The completed image was then saved as a TIFF file and used in a desktop publishing or word processing package to produce the stationery item masters. As the design is just black and white the items could then be reproduced using photocopy or cheap printing services

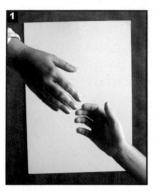

Capture the reaching hands picture

Download and crop image

Erase background

Convert image to just black and white

Stroke image outline

Erase imperfections

Clean up edge lines

Crop image to size and shape

Place image in layout program

Figure 8.13 (Full captions provided on page 159)

9 Creating Great Panoramas

Panoramic images have always been a very inspiring aspect of photography. Until now making these types of pictures has been restricted to a small set of lucky individuals who are fortunate enough to own the specialized cameras needed to capture the wide images. With the onset of the latest image-editing packages, software manufacturers have now started to include features that allow users with standard cameras to create wonderful wide-angle vistas digitally. See Figure 9.1.

These extra pieces of software are sometimes referred to as stitching programs, as their actual function is to combine a series of photographs into a single picture. The edge details of each successive image are matched and blended so that the join is not detectable. See Figure 9.2. Once all the photographs have been combined the result is a picture that shows a scene of any angle up to a full 360°. See Figure 9.3. Photomerge (File>Photomerge) is included free within Elements and is Adobe's version of the stitching technology.

Figure 9.1 Digital editing packages like Elements now include stitching packages that allow you to make dramatic panoramas from standard camera images

Figure 9.2 The panorama is made by stitching sequentially shot images together

Figure 9.3 The stitched result can be made up of many individual images and can encompass a view up to a full 360°

Taking Photomerge images

Although the Photomerge feature is designed to simplify and solve a lot of the problems associated with image stitching, a great deal of your own success will be based on how your source images are taken in the first

place. A little care and planning at the shooting stage can ensure a successful panorama with little or no 'touch-up' work later. Use the following guidelines to help capture those vistas.

Image overlap

Photomerge works on identifying common edge elements in sequential images and using these as a basis for blending the two pictures together. When you are making your source photographs ensure that they overlap by a minimum of 30% and a maximum of 70%. See Figure 9.4. These settings give the program enough information to ensure accurate stitching. I find that if I locate a feature about one-third of the way in from the right-hand side of the viewfinder (or display screen) in one shot and

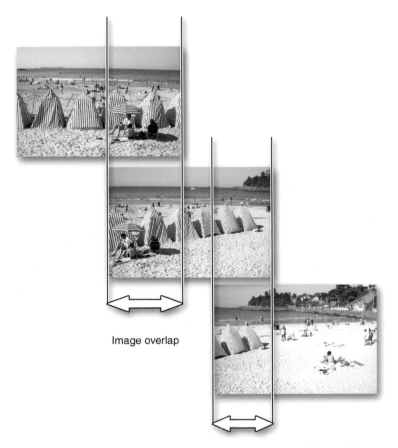

Image overlap

Figure 9.4 It is important to overlap source images by between 30 and 70%

then position the same detail one-third from the left in the next shot I end up with sufficient overlap for Elements to process the picture.

Keep the camera level

Although Photomerge is designed to adjust images that are slightly rotated it is far better to ensure that all source images are level to start with. The easiest way to achieve this is by photographing your scene with your camera connected to a level tripod with a rotating head. See Figure 9.5. If you are out shooting and don't have a tripod handy, try to locate a feature in the scene that remains horizontal in all shots and use this as a guide to keep your camera level when photographing your image sequence.

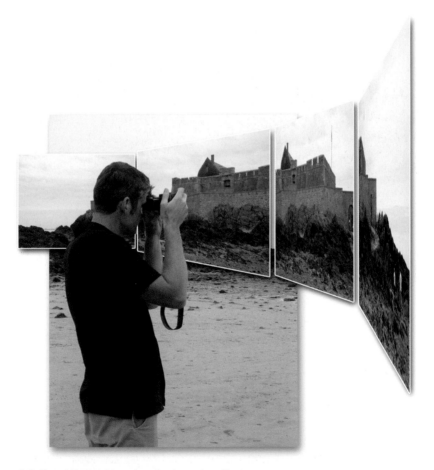

Figure 9.5 Keep the camera level when shooting your scene

Maintain focal length

Sometimes it is tempting to zoom in to capture a closer view of important details when you are in the middle of shooting a panorama sequence. Doing so will change the focal length of the lens and will make it very difficult or impossible to stitch this picture with all the others from the scene. Check what is the optimum focal length for the vista before starting to photograph and once you start to shoot don't touch the zoom control. See Figure 9.6.

Figure 9.6 Don't change focal length in the middle of a shooting sequence

Pivot around lens

Photomerge uses sophisticated perspective calculations to help reconstruct the scene you photographed. Changing your position even by a few inches will alter the perspective of all the images taken from that point on. Even the way that you hold and rotate the camera can alter the picture's vanishing point. To get the best results always try to pivot the camera

around the axis of its lens, this will ensure that all the images in your sequence will have a similar perspective. Special panoramic heads designed to position the lens above the center of the tripod are available for this purpose. See Figure 9.7. If you are capturing your scene with a hand-held camera then try to rotate your body around the camera not the other way around. See Figure 9.8.

Figure 9.7 A panoramic head for tripods is available for users who regularly shoot wide vistas (Source: Kaidan panoramic tripod heads)

Figure 9.8 If no tripod is available pivot the camera around its lens not around your body

Maximum image size = 2 megapixels

Adobe has designed its stitching program to be used with images of 2 megapixels or less. However, users with higher specification cameras do not need to shoot panoramic images at a lower resolution, as Photomerge can interactively reduce the size of source images at the time of acquisition.

Maintain exposure

Modern cameras contain specialized metering systems designed to obtain the best exposure for a range of lighting conditions. Each time the camera is aimed at a scene a new calculation is made for the brightest and darkest areas of the view. This system, though very helpful for normal picture taking, can be problematic when shooting panoramas, as the exposure needs to be constant throughout the shooting sequence. Changing the exposure settings automatically for different image parts of

Manual exposure

Figure 9.9 Change the exposure system to manual to keep images consistent

the same scene will mean that key areas will appear as different tones in the stitched picture. See Figure 9.9. If possible, you should change your camera's metering system to manual for the period whilst you are capturing panoramic source images to ensure consistent exposures.

Watch the edges

The edges of the image frame are the most critical part of the source picture. It is important to make sure that moving details such as cars, or pedestrians, are keep out of these areas. Objects that appear in the edge of one frame and not the next cause problems for the stitching program and may need to be removed or repaired later with other tools like the Clone Stamp. See Figure 9.10.

keep details in the middle of the frame

Figure 9.10 Try to avoid placing moving objects at the edge of frames, as they will disappear when the images are stitched

Starting the stitching process

Photomerge can work in automatic or manual mode. Both options are started using the Photomerge command found under the File menu. See Figure 9.11. Users are prompted by an initial dialog box to nominate the picture files that will be used to make up the panorama. It is possible to browse for these using the Add command. The selected files will then be listed in the Add box.

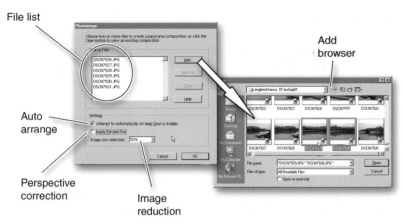

Figure 9.11 Pick the files you want to use for the stitching process using the Add dialog box

To get Elements to stitch the pictures for you, check the 'Automatically Arrange Source Images' box and click OK. You can also apply perspective corrections and reduce the size of image files larger than 2 megapixels using the settings in this box. The program will then load, match and stitch the image pieces together. In some instances, at the end of this process, Photomerge will display a small dialog window that will indicate that it has not been possible to stitch all pieces completely. See Figure 9.12. This is nothing to be concerned about, as a little fine-tuning is needed even with the best panoramic projects. Simply proceed to the next window, which is the Photomerge dialog box. See Figure 9.13.

Figure 9.12 A small dialog will display if Photomerge is unable to automatically arrange all source images. Click OK to proceed to the edit window

Alternatively leaving the 'Automatic' box unchecked will take you directly to the Photomerge dialog ready for manual layout of the panorama pieces.

Editing your panorama

Whilst in the Photomerge dialog you can use the Select Image tool to move any of the individual parts of the panorama around the composition or from the layout to the light box area. Click and drag to move image

Rotate image

Select image

Light box

Set vanishing point

Move view

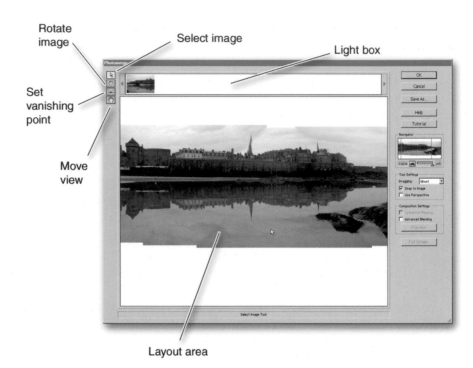

Layout area

Figure 9.13 The main Photomerge dialog allows you to edit and adjust the layout of your panorama

Click and drag

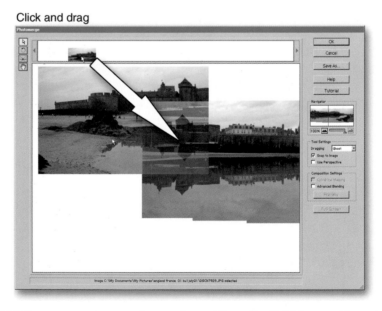

Figure 9.14 You can move source images to and from the light box and layout area by click and dragging them

parts. Holding down the Shift key will constrain movements to horizontal, vertical or 45% adjustments only.

The Hand or Move View tool can be used in conjunction with the navigator window to move your way around the picture. For finer control use the Rotate Image tool to make adjustments to the orientation of selected image parts. See Figure 9.14.

The 'Use Perspective' option together with the Set Vanishing Point tool manipulate the perspective of your panorama and its various parts. Keep in mind when using the perspective tools that the first image that is positioned in the composition area is the base image (blue border) and determines the perspective of all other image parts (red border).

To change the base image, click on another image part with the Set Vanishing Point tool. To correct some of the 'bow tie' like distortion that can occur when using these tools check the Cylindrical Mapping option in the Composition area of the dialog. See Figure 9.15. The Advanced Blending feature also available here can be used to help minimize color inconsistencies or exposure differences between sequential images.

It is not possible to use the perspective correction tools for images with an angle of view greater than 120°, so make sure that these options are turned off.

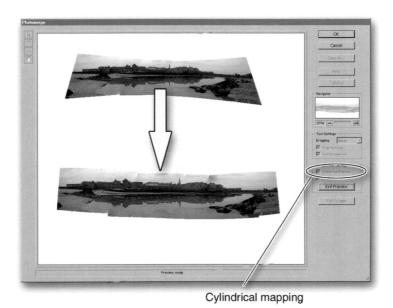

Cylindrical mapping

Figure 9.15 The Cylindrical Mapping feature will help correct the 'bow tie' effect that can result from perspective adjustments

After making the final adjustments the panorama can be completed by clicking the OK button in the Photomerge dialog box. This action creates a stitched file that no longer contains the individual images. An editable panoramic file (.pmg extension) that maintains the individual files as well as all the stitching settings can be saved by clicking the Save As button in the Photomerge dialog.

Feature summary

Starting a new panorama

1 Select Photomerge from the File menu (File>Photomerge) to start a new panorama.
2 Click the Add button in the dialog box.
3 Browse the thumbnails of your files to locate the pictures for your panorama.
4 Click the Open button to add files to the Source files section of the dialog.
5 Set the Image Size Reduction amount to reduce source file sizes. If you are using images greater than 2 megapixels then a setting of 50% or more should be used.
6 To get Elements to lay out the selected images check the 'Attempt to Automatically Arrange Source Images' box for manual layout control leave the box unchecked.
7 If you are using the 'Automatic Arrange' option then you can also choose to apply perspective correction across the whole of the composition. Do not use this feature if the panorama covers an angle of view greater than 120°.
8 Select OK to open the Photomerge dialog box.

Editing the layout of your source images

9 To change the view of the images use the Move View tool or change the scale and the position of the whole composition with the Navigator.
10 Images can be dragged to and from the light box to the work area with the Select Image tool.
11 With the Snap to Image function turned on, Photomerge will match like details of different images when they are dragged over each other.
12 Ticking the Use Perspective box will instruct Elements to use the first image placed into the layout area as the base for the composition of the whole panorama. Images placed into the composition later will be adjusted to fit the perspective of the base picture.

13 The Cylindrical Mapping option adjusts a perspective corrected image so that it is more rectangular in shape.

14 The Advanced Blending option will try to smooth out uneven exposure or tonal differences between stitched pictures.

Producing the panorama

15 The effects of Cylindrical Mapping as well as Advanced Blending can be viewed by clicking the Preview button.

16 The settings used for the panorama can be saved using the Save As option in the main Photomerge dialog.

17 The final panorama file is produced by clicking the OK button.

Real life digital imaging: constructing travel panoramas

Seeing new and different places can be a real 'eye opening' experience. The culture, people, architecture and clothing can vary so much from country to country that trying to take it all in, or worse, remember it, can be a difficult proposition. Most people prompt their memories with loads of photographs that, for many, spend more time in the drawer in the living room than being admired. Some pictures are framed and make it to the walls but it is only occasionally that these few pictures can sum up all of what the holiday traveler experienced. With stitching programs like Photomerge it is now possible to document a much wider view of the environment and all its differences. Hanging a few of these vistas on the wall will certainly bring back the sights and possibly even the sounds and smells of those distant shores. See Figure 9.16.

Web link: Make your own panorama from the example images on the book's website.

Figure 9.16 Holiday panoramic images can show a wider view of the traveler's environment

Captions to Figure 9.17 (see pages 175 and 176)

1 Find a suitable scene that contains interesting and memorable details in fore, mid and background areas. Set up your tripod or position yourself so that it is possible to record the action around you

2 Rotate the camera looking through the viewfinder but not taking any images, checking that the horizon is level and the zoom setting you have selected captures the main features of the scene

3 Set the aperture of the camera to a high f-stop number to ensure the sharpness of each picture extends from the foreground right into the distance

4 Set the exposure manually on an average between that needed for the brightest part of the scene and what is required for the dark areas

5 Start to photograph a sequence of images from left to right overlapping each sequential picture by a minimum of 30% and a maximum of 70%

6 Watch and wait for moving details to be positioned in the center of each shot. If this isn't possible take extra reference pictures so that the important details can be cut and pasted into the main composition later

7 Back at the hotel download the images onto your laptop and import them into Elements using the Photomerge option in the File menu

8 Browse for the panorama images using the Add button in the initial Photomerge dialog. Once found select all the pictures in the sequence and click the Open and then Add buttons

9 Tick the Attempt to Automatically Arrange Source Images option and then click the OK button

10 If Photomerge displays a small dialog that indicates that it has been unable to stitch all images automatically just click OK and move to the main Photomerge window

11 Adjust the view of the image using the Navigator control so that the whole composition can be seen

12 Drag and 'Snap to Image' any of the pictures that are still contained in the light box section of the dialog

13 Apply perspective correction to the image if needed by checking the box in the dialog

14 Tick the Cylindrical Mapping feature to help compensate for the bow tie effect that is caused by the perspective corrections. Use the Advanced Blending option to help disguise exposure changes

15 Produce the finale panorama by clicking the OK button. Use the cropping tool if necessary to trim the top and bottom of the image

Set up tripod

Check shooting environment

Set camera to high f-stop
number

Manually adjust exposure

Shoot a series of
overlapping images

Take care with edge
details

Download image
sequence

Add selected panoramic
image parts

Figure 9.17 (Full captions provided on page 174)

Select Automatically Arrange Source Images

Click OK

Adjust the Navigator view

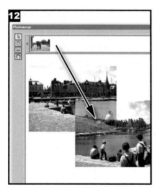

Arrange images not positioned

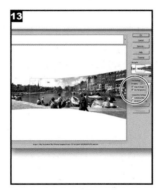

Apply perspective correction

Select the Cylindrical Mapping feature

Produce the final panorama

Figure 9.17 continued (Full captions provided on page 174)

10 Preparing Images for the Web or Email

If this book were being published a few years ago, it would have been sufficient for me to concentrate on the process of making great prints from digital files, but the impact of the Web is so great that knowing how to output your pictures so that they are suitable for the Web is not just a nice idea, it is essential. From its humble text-based beginnings the Net has become a very visual place. See Figure 10.1.

Figure 10.1 In the web age it is critical that users be able to output their images in a format that is suitable for net use

Images and the Net

As most people access the Web through a modem and telephone line the size of the images used for web work is critical. The larger the picture file, the slower it will download to your machine. So preparing your files for net use is about balancing picture quality and file size. To help with this two special image file formats, JPEG and

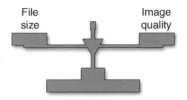

Figure 10.2 Preparing images for web use is concerned with balancing image quality and file size

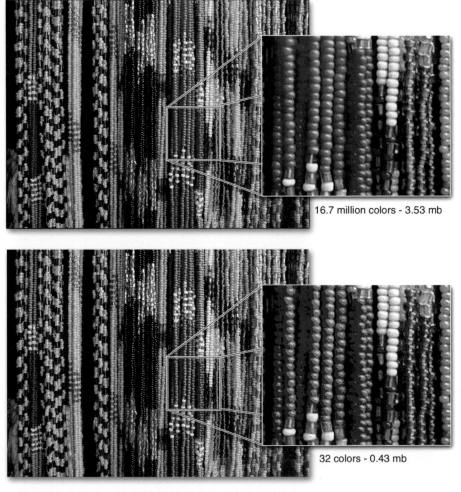

16.7 million colors - 3.53 mb

32 colors - 0.43 mb

Figure 10.3 The compression technology built into the GIF format makes files smaller by reducing the number of colors in your pictures to a maximum of 256 (8 bit)

GIF, have been developed, which include compression capabilities that shrink file sizes to a point where they can be used on a website or attached to emails. See Figure 10.2.

The problem with both file formats is that small file size comes at a cost of image quality. With the GIF or Graphics Interchange Format, it is only possible to save a picture with a maximum of 256 colors. As most photographic pictures are captured and manipulated in 24-bit, or 16.7 million colors, this limitation means that GIF images appear posterized and coarse compared to their full color originals. This isn't always the case, but because of the color restrictions this format is mainly used for logos and headings on web pages and not photographic imagery. GIF is also used for simple animations as it has the ability to flick through a series of images stored in the one file. See Figure 10.3.

In contrast the JPEG format was developed specifically for still images. It is capable of producing very small files in full 24-bit color. When saving in this format it is possible to select the level of quality, or the amount of compression, that will be used with a particular image. See Figure 10.4.

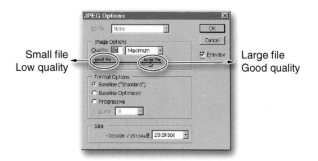

Small file
Low quality

Large file
Good quality

Figure 10.4 The compression level in the JPEG format is selectable via the quality slider in the JPEG dialog

Getting the balance right

Both formats make small files by using a 'lossy' compression algorithm. This means that image quality and information are lost as part of the compression process. In simple terms you are degrading the picture to produce a small file. Too much JPEG compression in particular, and the errors or 'artifacts' that result from the quality loss, becomes obvious. See Figure 10.5. So how much compression is too much? Well, Elements

adobe photoshop elements

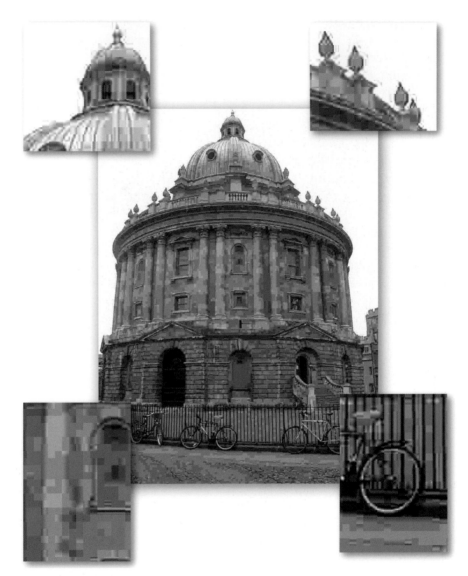

Figure 10.5 Too much JPEG compression introduces artifacts or errors into your pictures

includes a special 'Save for Web' feature that previews how the image will appear before and after the compression has been applied.

Start the feature by selecting the Save for Web option from the File menu. You are presented with a dialog that shows side-by-side, 'before and after' versions of your picture. See Figure 10.6. The settings used to compress the image can be changed in the top right-hand corner of the screen. Each time a value is altered, the image is recompressed using the

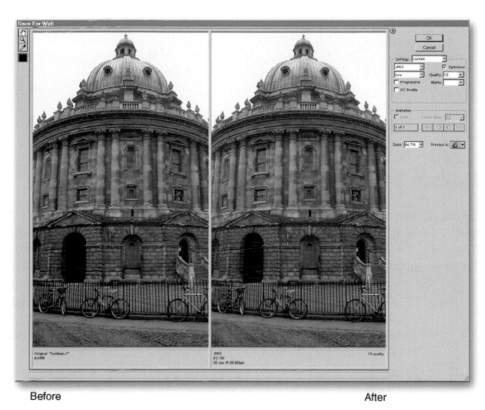

Before After

Figure 10.6 The Elements 'Save for Web' feature produces a side-by-side comparison of your image before and after compression

new settings and the results redisplayed. JPEG, GIF and another less popular web format, PNG, can all be selected and previewed in the Save for Web feature. By carefully checking the preview of the compressed image and the file size readout at the bottom of the screen it is possible to find a point where both the file size and image quality are acceptable. By clicking OK it is then possible to save a copy of the compressed file to your hard drive ready for attachment to an email or use in a web page.

Feature summary

1 With an image already open in Elements pick the Save for Web option (File>Save for Web).
2 Adjust the magnification of the images in the preview windows to at least 100% by using the Magnifying Glass tool or the Zoom drop-down menu.

3 Select the file format from the Settings area of the dialog.

4 Alter the image Quality for JPEG or the number of Colors for GIF.

5 Assess the compressed preview for artifacts and check the file size and estimated download times at the bottom of the dialog.

6 If the results are not satisfactory then change the settings and recheck file size and image quality.

7 Click OK to save the compressed, web ready file.

Making your own web gallery

Never before in the history of the world has it been possible to exhibit your work so easily to so many people for such little cost. The Web is providing artists, photographers and business people with a wonderful opportunity to be seen, but making your own website is considered by many a prospect too daunting to contemplate. Adobe has included in Elements an automated feature that takes a folder full of images and transforms them into a fully functioning website in a matter of a few minutes.

Figure 10.7 The Web Photo Gallery feature is located in the Automate section of the File menu

The Web Photo Gallery feature can be found under the Automate section of the File menu. See Figure 10.7. The main dialog contains sections where you can set the style of the website, the heading and colors used on pages and the source folder where your images are stored. The website itself is made up of a main or index page, a series of small versions of your pictures called thumbnails and a page for each image containing a larger gallery picture. You can navigate from one gallery page to another by clicking on the thumbnails. See Figure 10.8.

Built for speed

All your images will be converted to JPEG files in the process so there are also options to alter the compression rate used for your pictures as well as their final pixel dimensions. Changing these two settings will modify the

Figure 10.8 The photo gallery website is made up of a series of thumbnails and a set of gallery pages

final size of the image files, and as we are already aware, file size is linked to the download speed of the site. So finding a good balance of files size and image quality is the key to producing a series of pages that are easy to view. See Figure 10.9.

As there is no preview option in this Elements feature, it is worth making several different versions of the site containing images of varying sizes and compression rates. Each of the sites can then be tested for acceptable download speed and those that are deemed too slow can be deleted.

Going live

With the site completed the next step is to transfer all the files to some server space on the Net. Companies called ISPs, or Internet Service Providers, host the space. See Figure 10.10. The company that you are currently using for 'dial-up' connection to the Net will probably

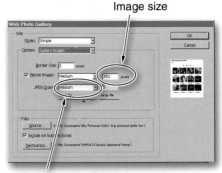

Figure 10.9 The image size and compression rate for each picture can be changed in the Gallery Images dialog

Figure 10.10 The completed website has to be transferred from your computer to a space on the Net hosted by an Internet Service Provider or ISP

provide you 5 to 10 MB of space as part of your access contract. As an alternative there are a range of hosting businesses worldwide that will store and display your gallery for free, as long as you allow them to place a small banner advertisement at the top of each of your pages.

Whatever route you take, you will need to transfer your site's files from your home machine to the ISP's machine. This process is usually handled by a small piece of software called an FTP or File Transfer Protocol

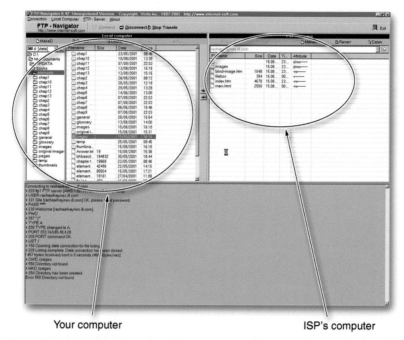

Your computer ISP's computer

Figure 10.11 File Transfer Protocol (FTP) software is used to upload your files to the Web

program. Your service provider or hosting company will be able to guide you step by step through this process. See Figure 10.11.

When Elements created your site the program made three folders or directories, titled 'images', 'thumbnails' and 'pages'. These were placed in your designated Destination folder along with two extra files – index.html and frameset.html. Together these are the core components of your website. See Figure 10.12.

Website components

Figure 10.12 Elements stores your website and its components in three folders and two extra files on your hard drive

Trouble-free web pages

To ensure that your site works without any problems, all of these components need to be uploaded to your ISP. You also shouldn't move, or rename, any of the folders, or their contents, as this will cause a problem when the pages are loaded into a web browser. See Figure 10.13. If you

Figure 10.13 To ensure that your website works, do not rename, or move, any of the files or folders that hold the components for your site

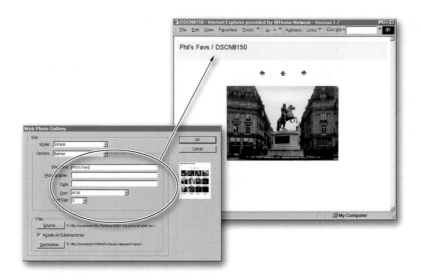

Figure 10.14 The Banner section of the Web Photo Gallery dialog contains settings for the site's heading area

want to add extra images to your site, or change the ones you have, then it is easiest to make a completely new site to replace the old version.

Feature summary

1 Select File>Automate>Web Photo Gallery.
2 Choose the look that you want for your website from the options available in the Style section of the dialog.

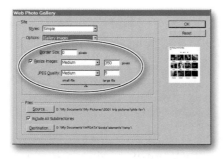

Figure 10.15 The settings in the Gallery Images section control the size and compression of the larger images in the site

3 Select the Banner item from the Options drop-down menu. Input the details for the site using the text boxes provided. See Figure 10.14.
4 Select the Gallery Images item from the Options drop-down menu. Adjust the size and compression settings to suit your images. Add a border to your pictures by inputting a border size. See Figure 10.15.
5 Select the Gallery Thumbnails item from the Options drop-down

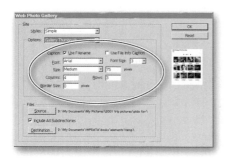

Figure 10.16 The design of the thumbnails layout for the website is determined by the settings in the Gallery Thumbnails section of the dialog

Figure 10.17 The color scheme for the website can be altered using the settings in the Custom Colors section

menu. Indicate if you want the File Name or File Info included with the thumbnails. Select the font style and size. Type in the pixel size and layout design (number of columns and rows) for the thumbnails. See Figure 10.16.

6 Select the Custom Colors item from the Options drop-down menu. Double click on each of the swatches to activate the color picker. Sample the new color from the dialog and click OK to set. See Figure 10.17.

7 In the Files section of the dialog nominate the directories or folders to use for source images and completed site files.

8 Click OK to start the site construction process. When completed the finished website will be displayed in your default browser.

Making simple web animations with Elements

In Chapter 6 we looked at how layers can be used to separate different image parts so that they are easier to enhance and manipulate. Here we will use layers to create simple animations for your website.

Traditional animation

Whether it is the production of a Disney classic, or the construction of a small moving cursor for your web page, the basics of making animations remain the same. A series of images, or frames, are created with slight changes recorded from one picture to the next. The sequence is then

adobe photoshop elements

compiled and each frame is shown in quick succession. As your eye sees a new image, your brain remembers the last, with the result that the still images appear to move.

Historically, the frame images were drawn and painted on a series of acetate cells. Large productions could use thousands of cells, each representing a small slice of movement, to produce just a few seconds of animation on screen. These days a lot of animation companies use digital versions of this old way of working, but despite all the technological changes, all animation is based on a sequence of still images.

Animation – the Elements method

Adobe has merged traditional techniques with the multi-layer abilities of its PSD file structure to give Elements users the chance to produce their own animations. Essentially the idea is to make an image file with several layers. See Figure 10.18. The content of each being a little different from the one before. The file is then saved in the GIF format. In the process each layer is made into a separate frame in an animated sequence. As GIF is used extensively for small animations on the Net, the moving masterpiece can be viewed with any web browser, or placed on the website to add some action to otherwise static pages.

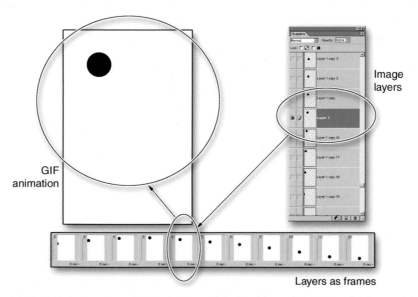

Figure 10.18 Each layer of a multi-layer Elements file becomes a different frame in a GIF animation

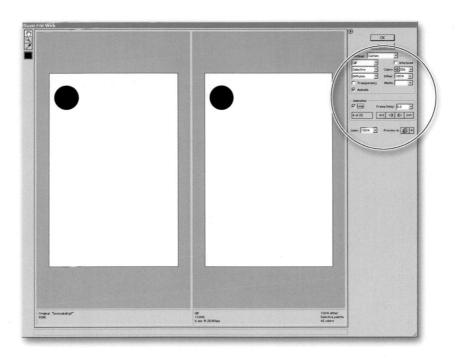

Figure 10.19 The 'Save for Web' feature provides a series of settings that controls the production of GIF animation files

The GIF file can be saved via the Save for Web feature or with the standard Save As command from the File menu. See Figure 10.19. If you use the 'Save As' route then you will need to click the 'Layers as Frames' option to save an animated file. Either pathway will lead you to the Save for Web dialog containing the original image and a GIF compressed version of the picture. By ticking the Animate checkbox you will be able to change the frame delay setting and indicate whether you want the animation to repeat (loop) or play a single time only. This dialog also provides you with the opportunity to preview your file in your default browser. The final step in the process is to click OK to save the file. See Figure 10.20.

Animation advice

Keep in mind when you are making your own animation files that GIF formatted images can only contain a maximum of 256 colors. This situation tends to suit graphic, bold and flat areas of color rather than the gradual changes of tone that are usually found in photographic images.

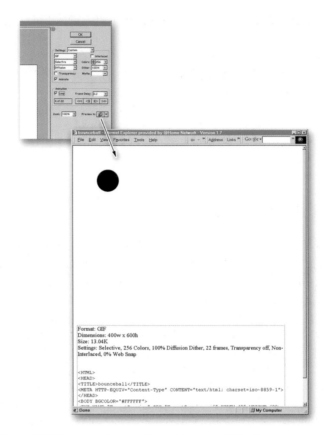

Figure 10.20 Your animation can be previewed in your default web browser directly from the Save for Web window

So rather than being disappointed with your results, start the creation process with a limited palette, this way you can be sure that the hues that you choose will remain true in the final animation. It is also worth remembering that the Elements animation feature is designed for short non-complex compositions. If you are planning a major epic made up of large, high resolution files that when compiled will play for an extended period of time, or even if you just want to add sound to your moving images, it would be best for you to use a dedicated animation package.

Feature summary

1 Create an Elements file with several layers of differing content.
2 Select File>Save for Web.

3 Ensure that the GIF setting is selected in the Settings section of the dialog.

4 Tick the Animate checkbox.

5 Adjust the Frame Delay option to control the length of time each individual image is displayed.

6 Tick the Loop checkbox if you want the animation to repeat.

7 Preview the animation by clicking the browser preview button. Close the browser to return to the Save for Web dialog.

8 Select OK to save the file.

Web Based Printing

In designing Elements Adobe realized that the Web plays, and will continue to play, a large role in the life of most digital image makers. The inclusion of a Web Based Printing option in the package shows just how far online technology has developed.

Although a lot of images that you make, or enhance, with Elements will be printed right at your desktop, occasionally you might want the option to output some prints on traditional photographic paper. The Online Services option, located in the File menu, provides just this utility. See Figure 10.21. Using the resources of Shutterfly.com in the USA, Elements users can upload copies of their favorite images to the company's site and have them photographically printed in a range of sizes. The finished prints will then

Figure 10.21 The Online Services feature allows you to print digital files photographically direct from your desktop

be mailed back to you. This service provides the convenience of printing from your desktop with the image and archival qualities of having your digital pictures output using a photographic rather than inkjet process.

Making your first web prints

Upon first selecting the Online Services feature you will need to select the Shutterfly.com option and work your way through several sign-up screens to register with the site. See Figure 10.22. With this completed the next time you select Shutterfly.com you will be provided with a dialog that will allow you to either select images from your hard drive to upload to the site, or transfer the picture you currently have open. Although Shutterfly.com does provide a set of online editing and enhancement tools I alter my images in Elements first before uploading. Once you have several images stored on the website in a picture album format, you can access the other Shutterfly.com options. The site contains many features designed to allow you to share your images with your friends and family in print or digital form. See Figure 10.23.

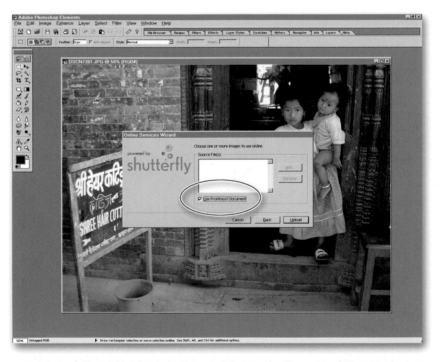

Figure 10.22 Images that are already opened in Elements can be uploaded directly to the Shutterfly.com website

Figure 10.23 The transferred images are stored in a series of photo albums on the Shutterfly.com website

If you like the look of true photographic quality prints then this online option provides a quick, easy and reliable service to output your digital images from your desktop.

Feature summary

To register

1 Select Online Services from the File menu.
2 Pick Shutterfly.com from the list and click Next.
3 Read information window and click Next.
4 Enter your email address and pick a password and enter it. Click Sign Up.
5 Follow the rest of Shutterfly.com's registration screens.

To upload files

1 Select Online Services from the File menu.
2 Pick Shutterfly.com from the list and click Next.
3 Enter your email address and password and click Next.
4 Select files from hard drive or click Use Foremost Document to load image currently open. Click Upload.

5 The transfer process can be monitored at the bottom of your Elements screen.
6 At the next screen click Upload More to add to your net files or Finish to return to Elements.

To web print

1 Perform steps 1 to 5 from the process for uploading files.
2 At the next screen click View on Web to connect you to the Shutterfly.com site.
3 Click the view tab and select the album containing the images to print.
4 Click the image to print and then click the Order Print option.
5 Select the addressee for the order and click Next.
6 Input size and quantity of prints and click Next.
7 Check the Order Summary and then click Order Now.

Real life digital imaging: a painterly cyber gallery

Rachel Haynes is a fine artist who creates paintings, works on paper and textile art. She exhibits her work regularly in a range of galleries in her home town. When she found out that it was possible to make a simple website displaying her work in a couple of hours she jumped at the chance.

Figure 10.24 Most artists document their artwork and exhibitions regularly. These images are a good starting point when collecting pictures for a Web Photo Gallery

Figure 10.25 The Elements generated site contains a front page with small thumbnails that when clicked take the viewer to larger versions of the work

Most artists document their work and their exhibitions regularly using slide or transparency film. This means that the first step in the website production process was to scan a range of existing slides. From here the images were adjusted and enhanced before being automatically converted by Elements into web pages. Space was then organized with a free Internet Service Provider and the new site's files and images uploaded from Rachel's home computer to the Net. See Figures 10.24 and 10.25.

Web link: Make your first website using the example gallery images from the book's website.

Captions to Figure 10.26 (see pages 197 and 198)

1 The documentary slides were cleaned and then scanned. The scanner was set to sample the images and produce files that were suitable for screen rather than print use

2 Each image was imported into Elements using the Acquire option in the Startup screen or by selecting the Import option of the File menu

3 Any distracting background details were cropped out of the digital files using the Crop tool

4 The contrast and brightness of the picture were adjusted using the Brightness/Contrast or Levels features (Enhance>Brightness/Contrast>Brightness/Contrast or Enhance>Brightness/Contrast>Levels)

5 Dominant casts were removed from the images using the Color Cast command (Enhance>Color>Color Cast)

6 The pictures were sharpened using the Unsharp Mask filter (Filter>Sharpen>Unsharp Mask)

7 Descriptions of the pictures were typed into the Caption section in the File Info dialog located under the File menu

8 The pixel dimensions of all images were adjusted so that they fitted within the boundaries of a standard screen using the Image>Resize>Image Resize feature

9 All the images were saved to a common directory or folder entitled Original Web Images

10 The Web Gallery feature was opened in Elements (File>Automate>Photo Web Gallery)

11 The Original Web Images directory was located and marked as the Source folder. A Destination folder was selected to hold the web components created by Elements

12 The Site Name, Photographer, Date, Font and Font Size were input into the Banner section of the dialog

13 In the Gallery Images section the Border and Image size as well as the level of JPEG compression to be used for the large images were set

14 The Use File Info Caption checkbox was ticked in the Gallery Thumbnails section and details about font styles and sizes were determined. The layout of the thumbnails was set by selecting the number of columns and rows to be used

15 The colors that were used for web components were set in the Custom Colors section of the Web Photo Gallery dialog. With all the settings complete the OK button was clicked to create the web gallery

16 Space was obtained from a free web Internet Service Provider

17 The ISP's built-in file transfer protocol program was used to upload the site's components

18 All the links of the new cyber art gallery were then checked using a web browser

Clean the slides to be scanned

Import images via scanner driver

Crop out unwanted details

Adjust contrast and brightness

Remove color casts

Sharpen images

Add descriptions

Adjust pixel dimensions

Save images to common directory

Figure 10.26 (Full captions provided on pages 195 and 196)

Start the Web Gallery feature

Select Source folder

Input site details

Adjust Gallery Images properties

Alter Gallery Thumbnail properties

Change Custom Colors

Choose an Internet Service Provider

Upload the site's components

Test the site

Figure 10.26 continued (Full captions provided on page 196)

11 Preparing Images for Printing

Despite the great rush of some picture makers to 'all things web', most digital images end up being printed at some stage during their existence. Contributing to this scenario is the current crop of affordable high quality inkjet printers whose output quality is nothing short of amazing. As little as 5 years ago it was almost impossible to get photographic quality output from a desktop machine for under £5000, now the weekend papers are full of enticing specials providing stunning pictures for as little as £200. See Figure 11.1.

Figure 11.1 Current inkjet printers are capable of providing photographic quality images and cost a fraction of comparative technology just a few years ago

The manufacturers have simplified the procedure of connecting and setting up their machines so much that most users will have their printer purring away satisfactorily within the first few minutes of unpacking the box. Software producers too have been working hard to simplify the printing process so that now it is generally possible to obtain good output from your very first page.

Elements is a good example of these developments providing an interactive printing system that previews the image on the paper background virtually before using any ink or paper to output a print. The package also includes the ability to print a section of an open image, make a contact sheet of images contained within a folder and produce a print package of different sized pictures optimized to fit on a specific paper stock. See Figure 11.2.

Contact print

Picture package

Single print

Figure 11.2 Elements contains an interactive print system that can not only produce single images, but also contact sheets and multi-print packages

Printing the Elements way

All of the print settings in Elements are contained in three separate but related dialog boxes – Print Preview (File>Print Preview), Page Setup (File>Page Setup) and Print (File>Print). See Figure 11.3.

Figure 11.3 The Print Preview, Page Setup and Print menu options contain all the settings used to control your printer and the quality of its output

Figure 11.4 You can change the size and position of your image on its paper background via the Print Preview dialog

The Print Preview dialog is the first stop for most users wanting to make a hard copy of their digital pictures. Here you can interactively scale your image to fit the page size currently selected for your printer. By deselecting the Center Image option and ticking the Show Bounding Box feature it is possible to 'click and drag' the image to a new position on the page surface. These features alone will make a lot of digital photographers very happy. See Figure 11.4.

Once you are satisfied with the picture size and position, you can proceed to the Page Setup dialog using the button provided. It is here that you are able to change the settings for the printer such as paper type, size and orientation, printing resolution and color control, or enhancement. The extent to which you will be able to manually adjust these features will

Figure 11.5 The Page Setup dialog gives you direct access to your printer's controls

depend on the type of printer driver supplied by the manufacturer of your machine. When complete click OK to return to the Print Preview dialog. See Figure 11.5.

To complete the process, click the Print button. This step produces a general print dialog where the user has another opportunity to check the printer settings via the Setup button, before sending the image on its way with a click of the OK button.

The link between paper type and quality prints

When you first start to output your own images the wide range of printer settings and controls can be confusing. At first it is best to stick to a

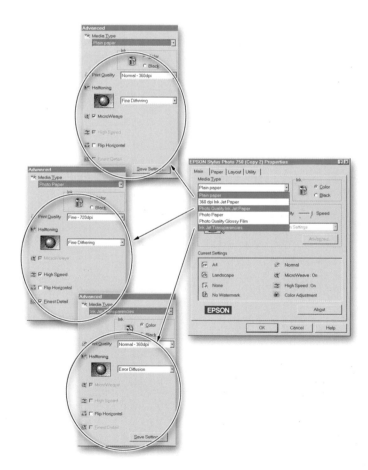

Figure 11.6 Selecting a paper type will adjust your printer to the optimum settings for the media

standard set-up and allow the built-in features of the driver to adjust the printer for you. For most printing tasks selecting the media type in the Print Properties dialog will be sufficient to ensure good results. The manufacturers have determined the optimum ink and resolution settings for each paper type, and for 90% of all printing tasks, using the default settings is a good way to ensure consistently high quality results. So if you are using gloss photographic paper, for example, make sure that you select this as your paper type in the printer settings dialog. See Figure 11.6.

Making your first print

With an image open in Elements, open the Print Preview dialog (File>Print Preview). Check the thumbnail to ensure that the whole of the picture is located within the paper boundaries. To change the paper's size or orientation, select the Page Setup and Printer Properties options. Whilst here adjust the printer output settings to suit the type of paper being used. Work your way back to the Print Preview dialog by clicking the OK buttons. See Figure 11.7.

To alter the position or size of the picture on the page deselect both Scale to Fit Media and Center Image options, and then select the Show Bounding Box feature. Change the image size by clicking and dragging

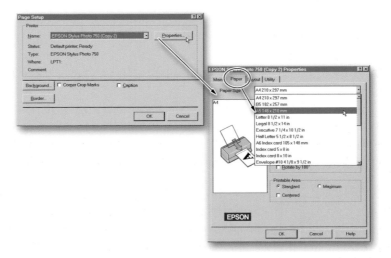

Figure 11.7 Change paper size, orientation and type via the Page Setup and Printer Properties dialogs

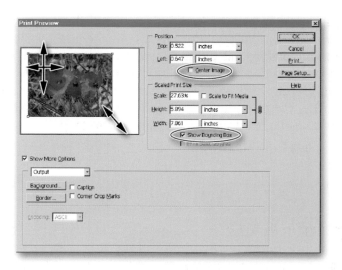

Figure 11.8 Change the size and position of the image on the page with the Print Preview dialog

the handles at the edge and corners of the image. Move the picture to a different position on the page by clicking on the picture surface and dragging the whole image to a different area. See Figure 11.8.

To print select the Print button and then the OK button.

Feature summary

1 Select Print Preview (File>Print Preview).
2 Click the Page Setup button.
3 Pick the printer Properties option to set the paper type, page size and orientation and print quality options.
4 Click OK to exit these dialogs and return to the Print Preview dialog.
5 At this stage you can choose to allow Elements to automatically center the image on the page (tick the Center Image box) and enlarge, or reduce, the picture so that it fits the page size selected (tick the Scale to Fit Media box).
6 Alternatively you can adjust the position of the picture and its size manually by deselecting these options and ticking the 'Show Bounding Box' feature. To move the image click inside the picture and drag to a new position. To change its size click and drag one of the handles located at the corners of the bounding box.
7 With all the settings complete click Print to output your image.

Printing a section of a full image

One very convenient feature of the Elements printing system is its ability to output a section of an image without having to modify the original picture itself. Simply pick the Rectangular Marquee tool and make a selection on the image surface. Proceed to the Print Preview dialog and select the Print Selected Area option. See Figure 11.9.

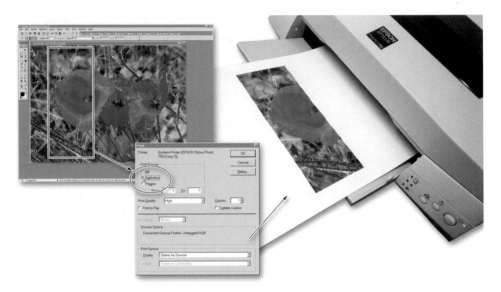

Figure 11.9 The Elements printing system allows the user to output a section of a full image

This feature is very useful for performing spot tests of important sections of large prints. The smaller prints will output faster than a full image and as long as the test areas are selected carefully, this process can be used to economically proof large and difficult images.

Feature summary

1 Select the area to be printed using the Rectangular Marquee tool.
2 Open the Print Preview dialog (File>Print Preview).
3 Tick the Print Selection option.
4 Click Print to output the selection.

Producing a contact sheet

In the last couple of years the digital camera market has exploded. Digital camera sales regularly outstrip their film-based counterparts over the same selling period. And with the onslaught of these new silicon shooters has come a change in the way that people take pictures.

Users are starting to alter the way that they shoot to accommodate the strengths of the new technology. One of these strengths is the fact that the act of taking a picture has no inherent cost. In comparison film-based shooting always involves a development cost associated with the production of negatives as well as the initial purchase of the film – digital picture taking is essentially costless. Yes there is the outlay for the camera and the expense associated with the storage, manipulation and output of these images, but the cost of shooting is zero. Hence, it seems that the typical digital camera user is shooting more pictures, more often, than they were when capturing to film. See Figure 11.10.

Digital photographers are not afraid to shoot as much as they like because they know that they will only have to pay for the production of the very best of the images they take. As a consequence, hard drives all over the country are filling up with thousands of pictures. Navigating this array of images can be quite difficult and a lot of people still prefer to edit their

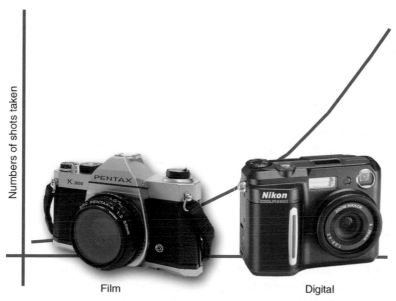

Figure 11.10 As there is no cost associated with shooting, digital camera users now take more pictures than when they were using film-based cameras

shots as prints rather than on screen. The people at Adobe must have understood this situation when they developed the Contact Print feature for Photoshop, and now Elements.

With one simple command (File>Automate>Contact Sheet) the imaging program creates a series of small thumbnail versions of all the images in a directory or folder. These small pictures are then arranged on pages and labelled with their file names. From there it is an easy task to print a series of contact sheets that can be kept as a permanent record of the folder's images. The job of selecting the best images to manipulate and print can then be made with hard copies of your images without having to spend the time and money to output every image to be considered. See Figure 11.11.

Figure 11.11 The contact sheet feature creates thumbnail versions of all the images within a selected folder or directory

The options contained within the Contact Sheet dialog allow the user to select the folder where the images are stored, the page size and to decide the size and the number of thumbnails that will be placed on this page. See Figure 11.12.

Image folder

Print size

Thumbnails
per page

Figure 11.12 The options in the Contact Sheet dialog allow the user to select the image folder, the number of thumbnails per page and the final print size

Feature summary

1 Select File>Automate>Contact Sheet II.
2 Use the Choose button to pick the folder or directory containing the images to be placed on the contact sheet.
3 In the Document area input the values for width, height, resolution and mode of the finished contact sheet.
4 In the Thumbnails section select the Place or sequence used to layout the images, as well as the number of columns and rows of thumbnails per page. Keep in mind that the more images you have on each page the smaller they will be. If the folder you selected contains more images than can fit on one page Elements will automatically make new pages to accommodate the other thumbnails.
5 In the final section you can elect to place a file name, printed as a caption, under each image. The size and font family used for the captions can also be chosen here.
6 Click OK to make the contact sheet.

Making a print package

At some stage in your digital imaging career you will receive a request for multiple prints of a single image. The picture might be the only shot available of the winning goal from the local football match, or a very, very cute picture of your daughter blowing out the candles on her birthday cake, but whatever the story, multiple requests mean time spent printing the same image. Adobe included the Picture Package feature in its Elements and Photoshop packages to save you from such scenarios.

Figure 11.13 The Picture Package option lays out multiple versions of the same image on a single sheet of paper

Found in the same Automate section of the File menu as the Contact Sheet command, Picture Package allows you to select one of a series of pre-designed, multi-print, layouts that have been carefully created to fit many images neatly onto a single sheet of standard paper. There are designs that place multiples of the same size pictures together and those that surround one or two larger images with many smaller versions. Whichever design you pick, this feature should help you to keep both family members and football associates supplied with enough visual memories to make sure they are happy. See Figure 11.13.

Feature summary

1 Select File>Automate>Picture Package.
2 In the Source Image section of the dialog box use the Choose button to pick the image you want as a base picture. Alternatively tick the Use Frontmost Document box to make use of an image already open in Elements.
3 Use the Layout drop-down menu to select a multi-print design. See Figure 11.14.
4 Specify a Resolution and color mode to suit the package.
5 Click OK to make the Picture Package.

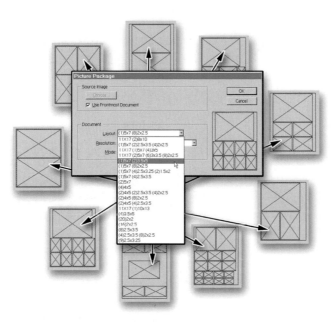

Figure 11.14 Many designs are included in the Layout drop-down menu of the Picture Package feature

Aiming for the best quality – balancing image size and quality

The printing techniques detailed above can be used for producing good prints for the majority of images, papers, inks and printers. To gain the ultimate in control over your printed output, however, you need to delve a little deeper. Let's start by revisiting the factors that underpin good image quality.

Good prints are made from good images, and we know from previous chapters that digital image quality is based on high image resolution and high bit depth. Given this scenario, it would follow that if I desire to make the best prints possible, then I should at first create pictures with massive pixel dimensions and huge numbers of colors. The problem is that such files take up loads of disk space and, due to their size, are very, very slow to work with, to the point of being practically impossible to edit on most desktop machines.

Figure 11.15 Good prints are made from files that balance file size and image quality

Figure 11.16 *The three practical factors that govern all printed output are the printer mechanism, the inks used and the paper or media printed on*

The solution is to find a balance between image quality and file size that still produces 'good prints'. See Figure 11.15. For the purposes of this book 'good prints' are defined as those that appear photographic in quality and can be considered visually 'pixel-less'. The quality of all output is governed by a combination of the printer mechanism, the ink set used and the paper, or media, the imaged is printed on. To find the balance that works best with your set-up you will need to perform a couple of simple tests with your printer. See Figure 11.16.

Getting to know your printer – testing tones

There are 256 levels of tones in each channel (Red, Green and Blue) of a 24-bit digital image. A value of 0 is pure black and one of 255 is pure white. Desktop inkjet machines do an admirable job of printing most of these tones but they do have trouble printing delicate highlight (230–255) and shadow (0–40) details. Some machines will be able to print all 256 levels of tones, others will only be able to output a smaller subset. See Figure 11.17.

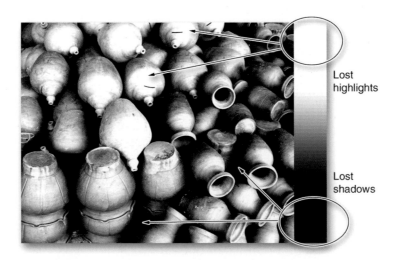

Lost highlights

Lost shadows

Figure 11.17 *Some printers are capable of outputting all tones in an image, others lose delicate highlight and shadow details in the printing process*

To test your own printer/ink/paper set-up make a stepped grayscale that contains separate tonal strips from 0 to 255 in approximately five tone intervals. Alternatively download the example grayscale from the book's website. Print the grayscale using the best quality settings for the paper you are using. Examine the results. In particular, check to see at what point it becomes impossible to distinguish dark gray tones from pure black and light gray values from white. Note these values down for use later as they represent the range of tones printable by your printer/paper/ink combination. See Figure 11.18.

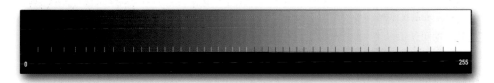

Figure 11.18 Print the example grayscale noting down the tones that your machine fails to print

When you are next adjusting the levels of an image to be printed, move the output sliders at the bottom of the dialog until black and white points are set to those you found in your test. The spread of tones in your image will now meet those that can be printed by your printer/paper/ink combination. See Figure 11.19.

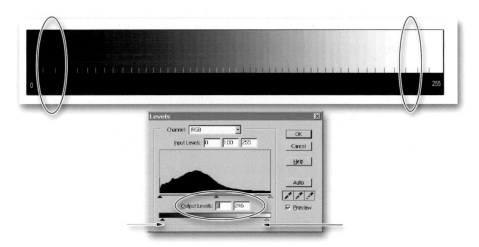

Figure 11.19 Drag the black and white output sliders till they match the values of those found in the grayscale or tone test

Getting to know your printer – testing resolution

Modern printers are capable of incredible resolution. Some are able to output discrete dots at a rate of almost 3000 per inch. A lot of users believe that to get the utmost detail in their prints they must match this printer resolution with the same image resolution. Although this seems logical, good results can be achieved where one pixel is printed with several printer dots. Thank goodness this is the case, because the result is lower resolution images and therefore more manageable, and smaller, file sizes. But the question still remains – exactly what image resolution should be used?

Again a simple test can help provide a practical answer. Create a high resolution file with good sharp detail throughout. Using Image>Resize >Image Size makes a series of 10 pictures from 1000 dpi to 100 dpi reducing in resolution by a factor of 100 each time. Alternatively download the resolution examples from the book's website.

Now print each of these pictures at the optimum setting for your machine, ink and paper you normally use. Next examine each image carefully. Find the lowest resolution image where the picture still appears photographic. This is the minimum image resolution that you should use if you want your output to remain photographic quality.

For my set-up this setting varies from between 200 and 300 dpi. I know if I use these values I can be guaranteed good results without using massive file sizes.

Getting to know your printer – managing color

As computer operating systems have developed, so too have the way that they have handled the management of color from capture through the manipulation phase to output. A central part of this process is a group of settings, called a color profile, that govern the conversion of an image's color from one device to another. A well-calibrated system will contain a profile for scanner, screen and printer so that the image is passed from one managed space to another.

When printing with Adobe Elements it is possible to select the type of color management you want to apply to the output. If your printer came supplied with a profile you can select it in the Print Space area of the Print Preview dialog. You might have to select More Options to make this part of the dialog visible. If no profile is supplied then you can either elect to

Figure 11.20 If your printer is supplied with a color profile use the extended options in the Print Preview or Print dialogs to nominate this set of preferences as your preferred method of color management

Figure 11.21 Rid images of persistent casts using the color slider settings built into your printer's driver software

use the same space the image was captured in or elect to use the printer color management built into the driver. See Figure 11.20.

For the majority of output scenarios these options will provide good results. If you do happen to strike problems where images that appear neutral on screen continually print with a dominant cast then most printer drivers contain an area where individual colors can be changed to eliminate casts. See Figure 11.21.

Real life digital imaging: a digital photographer's tale

For a photographer shooting everything in a digital format means a major change in the way that he or she works. No longer are desks and light boxes covered with negative files or slide pages. The pictures reside neatly on the hard disk of their computers. Selecting and editing these pictures is often just a prelude to the main objective of obtaining a fine quality print.

It is here that Elements' printing system plays a key role, at first by making a contact sheet that the photographer can use as reference and then by outputting a single print or even a multi-print package. See Figure 11.22.

Web link: Make a print package using the example image from the book's website.

Captions to Figure 11.22 (see page 217)

1 Most digital photographers download the images from their computers after a day's shooting. Unlike film there is no need to wait until all the space on the camera's digital film is used before it can be unloaded
2 During the transfer from camera to computer it is good practice to make a new folder for the pictures using a name that is representative of the image content
3 Open the Contact Sheet feature in Elements (File>Automate>Contact Sheet II) and select the folder or directory containing the new images
4 Set the page size, mode and number of thumbnails to be created per page. Tick the Use Filename as Caption option and select the font and size
5 Click OK to create the contact sheet. Save the new file in the same folder as the images for later reference and then print the contact sheet
6 Using the contact sheet as reference select an image to be edited in Elements. Once opened use the settings from the resolution test to set the image resolution of the picture (Image>Resize>Image Size)
7 Open the Levels dialog (Enhance>Brightness/Contrast>Levels) and drag the Output sliders until the settings match those found previously with the tone tests
8 Open the Print Preview dialog (File>Print Preview) and check to see via the Page Setup and Printer Settings windows that the media, paper orientation and size settings are correct
9 Click the Show More Options at the bottom of the Print Preview window and load the color profile for your printer before outputting your image

Download images to computer

Make new folder for images

Activate the Contact Sheet feature

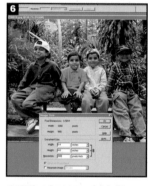

Set Contact Sheet properties

Create and save new contact sheet

Set the image resolution

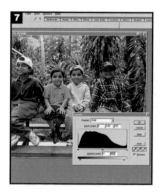

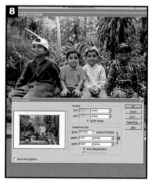

Adjust tonal values

Preview print settings

Load color profile

Figure 11.22 (Full captions provided on page 216)

12 Where to From Here

I started this book by applauding Adobe for their foresight in releasing Elements, because in doing so they had obviously realized the importance of a huge group of users who wanted the power of Photoshop but didn't need all the features. I hope that the last few chapters have demonstrated that for 95% of your digital imaging needs Elements should be your first port of call. Most users will find that this package more than covers their entire image-editing requirements, but as you develop your skills and understanding some of you will arrive at a point where you need some of the professional features contained in Photoshop. To help you decide when this day has arrived this chapter will look at the differences between Elements and the Adobe image-editing flagship – Photoshop.

The differences between Elements and Photoshop

From the onset it is important to understand that Photoshop is a professional imaging tool. In the current industry climate this means that not only does the software contain 'bullet-proof' editing and enhancement features, but it also must allow users to output files that are customized for high quality offset printing and web production. For this reason Photoshop contains many features dealing with these areas.

Offset printing

Although Elements is more than sufficient for making prints with most desktop inkjet machines, Photoshop can create and edit images in the CMYK (Cyan, Magenta, Yellow and Black) press format. See Figure 12.1.

Figure 12.1 *Images destined for publication in magazine or book form are separated into Cyan, Magenta, Yellow and Black (or CMYK) components*

This four-color separation mode is the basis of most offset printing and Photoshop's ability to work with these files is the reason why it has become a favorite software tool of printers all over the world.

Unlike Elements the mode section in Photoshop contains extra options for the conversion of images to CMYK and Duotone as well as specialist LAB and Multi-channel formats. The options in the Show Info feature reflect the different modes available in each package. Photoshop also provides the ability to output the separation images needed to make printing plates directly. See Figures 12.2 and 12.3.

Ink color 1 Ink color 2 Duotone image

Figure 12.2 Duotone is a special printing mode that colors a monotone image by using two separate printing inks

Photoshop Show Info Elements Show Info

Figure 12.3 Photoshop's Show Info contains more display and sampling options than the reduced set found in the Elements version

Web-based production

Adobe has deemed quality output to the Net to be so important that a few years ago they created a totally new product call ImageReady. Supplied free with Photoshop, ImageReady is a dedicated image-editing package designed to produce web components such as animations, rollovers, image slices and maps. See Figures 12.4 and 12.5.

The animations features extend the basic abilities found in Elements and provide more creative control over how each individual frame fits within a GIF animation.

Rollovers are a specialist button type that has gained in popularity over the last few years. ImageReady not only allows the user to set up the pictures that will be used for the button, but the program also writes the special code that is needed to make the button function. See Figure 12.6.

Some advance features in web imaging require an image to be sliced into smaller image segments. Photoshop and ImageReady contain advanced features for editing of web images and their sliced components.

adobe photoshop elements

Figure 12.4 ImageReady is a stand-alone editing program that is used to optimize and create web images

Figure 12.5 You can jump between Photoshop and ImageReady by using the extra button located at the bottom of the toolbar

Mouse off Mouse over

ImageReady rollover setup

Figure 12.6 The main image in a rollover button changes when the mouse pointer moves over it

Image maps allow users to allocate different button features and web links to small sections of a large image, and also to allow areas of an image that contain more or less detail to be compressed by differing amounts. ImageReady provides a toolset designed to construct, edit and maintain the image maps within a website.

Through the use of these special features users can optimize their existing images for the Web or create totally new web elements not possible in Photoshop or Elements alone.

The other main differences revolve around features that allow finer control of images, their tones and hues. In particular Photoshop contains advanced color management settings, inbuilt masking tools, curves functions, extended selection capabilities and special paths features.

Color management

It is assumed that most Photoshop users will be professional imaging specialists. As such, the program contains sophisticated color management controls that can be customized to suit a myriad of output scenarios. This level of color organization makes Photoshop the pivot point for digital image creation, manipulation and output. Professionals who are involved

Figure 12.7 The advanced color management features in Photoshop provide a common base for conversion of color images as they are passed from one person to another along the production line

at different points in the process can pass image files to each other, being secure in the knowledge that Photoshop will adjust picture data to suit their imaging set-up. See Figure 12.7.

In contrast, Elements' color management is designed for use with a single digital set-up – a camera connected to a computer linked to a printer. It performs this job admirably but if your business involves inputting and outputting files from a range of sources to a variety of destinations with the best color management available, then there is no other choice than to use Photoshop.

Automated functions

A feature that was introduced to Photoshop a few versions ago was the ability to be able to record a series of actions, which could be replayed later. For those users whose daily work involves a series of repetitive image changes this feature was a godsend. To some extent the Layer Styles in Elements is a more basic version of the technology. Here the repeated actions that would need to take place to make a drop shadow,

Figure 12.8 Photoshop's Action feature allows the recording and playback of a series of production steps

for instance, have been collated and are performed at the push of a single button. The 'Actions' feature in Photoshop takes this idea further by allowing users to record and organize their own series of steps. See Figure 12.8.

There are now dedicated websites that house thousands of Photoshop actions that are designed to make the professional's day-to-day imaging tasks much simpler. Unlike Elements, the Photoshop batch is able to apply any action to a group of images within a specific folder.

Selections and paths

Although the tools are similar in both Adobe packages, Photoshop has the added ability of being able to save complex selections as part of the PSD file. With this feature the precise outline of an image part, made with many minutes of painstaking lasso work, can be reused time and time again, even after the file has been closed and reopened. See Figure 12.9.

Photoshop also supplies a series of tools designed to create and edit paths. Creating a path is similar to making a selection. The Pen is used to make the path outline around image parts. Like the Polygonal Lasso, the Pen lays down anchor points between which a straight line is drawn. When complete, the path can be saved as part of the image file. Anchor points can be added to and removed from the path at any time. The

Figure 12.9 Being able to save complex selections as part of a Photoshop file is a real advantage

position of any point can be moved and the line that stretches between two points can be adjusted to fit image curves. And if all these features didn't impress you, a saved path can be converted to an active selection at any time. See Figure 12.10.

The extra editing abilities of paths make this tool a more sophisticated way to select areas within your image than the selection options available in either Photoshop or Elements.

Masking

Masking has its roots in traditional printing techniques where a ruby colored film was used to protect parts of the image during exposure. Photoshop contains a masking option that is designed for exactly the same purpose, that of protecting the image when changes are made. Accessed by clicking the QuickMask Edit button at the bottom of the toolbar, this feature allows users to use the drawing tools to paint a 'digital' ruby mask over the surface of their image. When a filter, tone or color

Figure 12.10 Path tools offer a more sophisticated and editable pathway to making selections

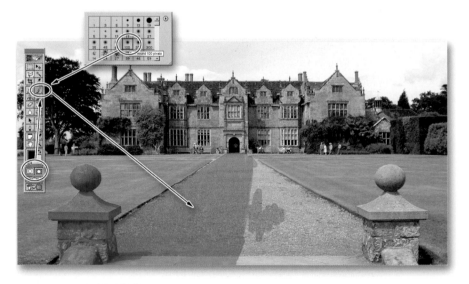

Figure 12.11 The QuickMask feature allows users to paint a red mask onto the image area, which then protects these parts of the picture from changes

change is applied to the image, the area covered by the mask is protected from the effects. Although you can achieve a similar result in Elements using careful selections, Photoshop's Mask feature gives the user ultimate control over where and how effects are applied. See Figure 12.11.

Curves

The characteristic curve is a familiar sight to a lot of photographers. It is used to describe how the tones in the shadow, highlight and midtone areas are spread throughout an image. In effect, it is another way to represent the information contained in the Levels dialog, with the difference that Curves allows you to interact and change very specific groups of tones. Dedicated Photoshop users often use this feature to make very slight but visually important corrections to areas such as the shadow details of a picture. See Figure 12.12.

Color Balance

As a lot of Photoshop users have a background in traditional photography, Adobe included a hue control in Photoshop that works in a similar way to the sliders or dials of a color enlarger. The Color Balance feature contains

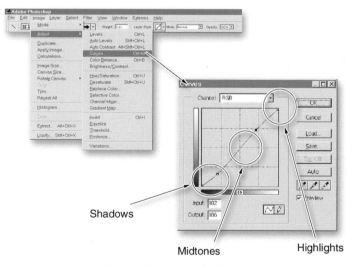

Shadows

Midtones

Highlights

Figure 12.12 Curves provides advanced tonal control of delicate areas such as shadows and highlights

three sliders – yellow/blue, magenta/green and cyan/red. The dominant color of any image can be changed by adjusting the mix of these three spectra. It is also possible to alter the cast of highlights, midtones and shadows independently.

Who can guide me further?

With the previous versions of this book never straying from the top ten digital imaging publications for photographers at Amazon.com, Martin Evening's *Adobe Photoshop for Photographers* is the book to introduce you to the sophistication of this powerful program. The current edition is updated to include the new features and functions contained in the latest release of the industry-leading, image-editing software.

Evening's style is ever practical as he provides step-by-step guides and tutorials loaded with real life examples and pragmatic advice. Also included with the volume is a CD ROM containing tryout software and example images. If you are moving from Elements to Photoshop and are looking for a way to master techniques that will give you professional looking results then this book is for you.

13 Jargon Buster

A

Aliasing The jaggy edges that appear in bitmap images with curves or lines at any angle other than multiples of 90°. The anti-aliasing function in Elements softens around the edges of images to help make the problem less noticeable. See Figure 13.1.

Figure 13.1 Aliasing is most noticeable on edges of text and objects

Aspect ratio This is usually found in dialog boxes concerned with changes of image size and refers to the relationship between width and height of a picture. The maintaining of an image's aspect ratio means that this relationship will remain the same even when the image is enlarged or reduced. See Figure 13.2.

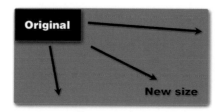

Figure 13.2 Maintaining the aspect ratio of your photograph when you enlarge or reduce sizes will guarantee that all your picture elements remain in proportion

B

Background printing Is a printing method that allows the user to continue working whilst an image or document is being printed.

Batch processing Refers to a function or a series of commands being applied to several files at one time. This function is useful for making the same changes to a folder full of images. In Elements this function is found under the Automate section of the File menu and is useful for converting groups of image files from one format to another. See Figure 13.3.

Figure 13.3 The batch mode in most image-editing products helps apply a collection of commands to several images automatically

Bit Stands for 'binary digit' and refers to the smallest part of information that makes up a digital file. It has a value of only 0 or 1. Eight of these bits make up one byte of data.

Bitmap, 'or raster' Is the form in which digital images are stored and is made up of a matrix of pixels.

Blend mode The way in which a color or a layer interacts with others. The most important after Normal are probably Multiply, which darkens

everything, Screen, which adds to the colors to make everything lighter, Lighten, which lightens only colors darker than itself, and Darken, which darkens only lighter colors than itself. Both the latter therefore flatten contrast. Color maintains the shading of a color but alters the color to itself. Glows therefore are achieved using Screen mode, and Shadows using Multiply.

Brightness range The range of brightnesses between shadow and highlight areas of an image.

Burn Tool to darken an image, can be targeted to affect just the Shadows, Midtones or Highlights. Opposite to Dodge. Part of the toning trio, which includes the Sponge.

Byte This is the standard unit of digital storage. One byte is made up of 8 bits and can have any value between 0 and 255. 1024 bytes is equal to 1 kilobyte. 1024 kilobytes is equal to 1 megabyte. 1024 megabytes is equal to 1 gigabyte.

C

CCD or Charge Coupled Device
Many of these devices placed in a grid format comprise the sensor of most modern digital cameras. See Figure 13.4.

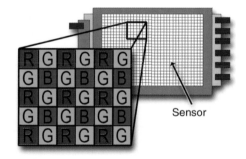

Clone Stamp tool Allows a user to copy a part of an image to somewhere else. It is therefore ideal for repair work, e.g. unwanted spots or blemishes. Equivalent to Copy and Paste in a brush.

Figure 13.4 The CCD sensor is the digital equivalent of film

Color mode The way that an image represents the colors that it contains. Different color modes include Bitmap, RGB and Grayscale. See Figure 13.5.

Compression Refers to a process where digital files are made smaller to save on storage space or transmission time. Compression is available in two types – lossy, where parts of the original image are lost at the compression stage, and lossless, where the integrity of the file is maintained during the compression process. JPEG and GIF use lossy compression where as TIFF is a lossless format.

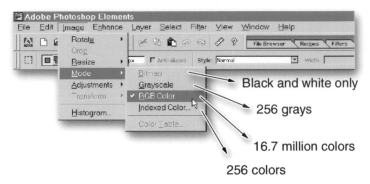

Figure 13.5 The mode of an image determines the number of colors that can be used in the picture

D

Digitize This is the process by which analogue images or signals are sampled and changed into digital form.

Dodge Tool for lightening areas in an image. See also **Burn**.

DPI Dots per inch is a term used to indicate the resolution of a scanner or printer. See Figure 13.6.

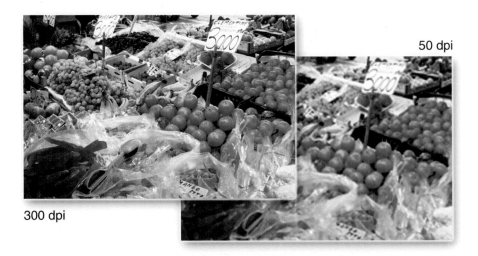

Figure 13.6 The dpi is a measurement of the resolution of the image

Dynamic range Is the measure of the range of brightness levels that can be recorded by a sensor.

E

Enhancement Is a term that refers to changes in brightness, color and contrast that are designed to improve the overall look of an image.

F

File format The way that a digital image is stored. Different formats have different characteristics. Some are cross-platform, others have inbuilt compression capabilities.

Filter In digital terms a filter is a way of applying a set of image characteristics to the whole or part of an image. Most image-editing programs contain a range of filters that can be used for creating special effects. See Figure 13.7.

G

Gamma Is the contrast of the midtone areas of a digital image.

GIF Graphic Interchange Format. This is an indexed color mode that contains a maximum of 256 colors that can be mapped to any palette of

Figure 13.7 Elements contains a host of filters that can change the look of your digital images

actual colors. It is extensively used for web graphics as buttons and logos, and small animated images.

Grayscale A monochrome image containing 256 tones ranging from white through a range of grays to black.

Gaussian Blur When applied to an image or a selection, this filter softens or blurs the image.

Gamut The range of colors or hues that can be printed or displayed by particular devices.

H

Histogram A graph that represents the distribution of pixels within a digital image. See Figure 13.8.

Figure 13.8 The Histogram is a visual representation of the pixels that make up your digital image

History Adobe's form of Multiple Undo.

Hue Refers to the color of the light and is separate from how light or dark it is.

I

Interpolation This is the process used by image-editing programs to increase the resolution of a digital image. Using fuzzy logic the program makes up the extra pixels that are placed between the original ones that were generated at the time of scanning.

Figure 13.9 Layers help keep separate different parts of a complex image

Image layers Images in Elements can be made up of many layers. Each layer will contain part of the image. When viewed together all layers appear to make up a single continuous image. Special effects and filters can be applied to layers individually. See Figure 13.9.

J

JPEG A file format designed by the Joint Photographic Experts Group that has inbuilt lossy compression that enables a massive reduction in file sizes for digital images. Used extensively on the web and by press professionals for transmitting images back to news desks worldwide. See Figure 13.10.

L

Layer opacity The opacity or transparency of each layer can be changed independently. Depending on the level of opacity the parts of the layer beneath will become visible. You can change the opacity of each layer by moving the Opacity slider in the Layers palette.

LCD or Liquid Crystal Display A display screen type used in preview screens on the back of digital cameras and in most laptop computers.

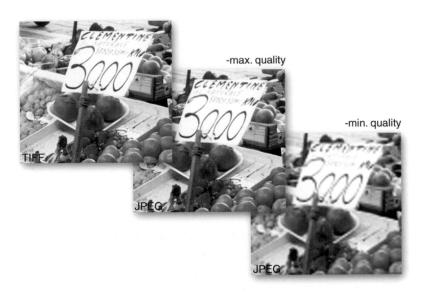

Figure 13.10 The compression of a TIFF file is 'lossless', whereas JPEG's compression system is 'lossy'

Liquify A tool that uses brushes to perform distortions upon selections or the whole of an image as if the image were on a piece of plasticine or dough.

M

Marquee A rectangular selection made by clicking and dragging to an opposite corner.

Megapixel One million pixels. Used to describe the resolution of digital camera sensors.

N

Navigator In Elements, a small scalable palette showing the entire image with the possibility of displaying a box representing the current image window frame. The frame's color can be altered; a new frame can be drawn (scaling the Image window with it) by holding the Command/Ctrl keys and making a new marquee. The frame can be dragged around the entire image with the Hand tool. The Zoom tools (mountain icons) can be clicked, the slider can be dragged, or a figure can be entered as a percentage.

O

Optical resolution The resolution that a scanner uses to sample the original image. This is often different from the highest resolution quoted for the scanner as this is scaled up by interpolating the optically scanned file.

Options bar Long bar beneath the menu bar, which immediately displays the various settings for whichever tool is currently selected. Can be moved to the bottom of the screen if preferred.

P

Palette A window that is almost always permanently accessible for the alteration of image characteristics: Options palette, Layers palette, Styles palette, Hints palette, File Browser, History, etc. These can be docked together vertically around the main image window or if used less frequently can be docked in the Palette Well at the top right of the screen (dark gray area). See Figure 13.11.

Figure 13.11 Palettes are a good way for image-editing software to provide a range of user options

Pixel Short for picture element, refers to the smallest image part of a digital photograph. See Figure 13.12.

Q

Quantization Refers to the allocation of a numerical value to a sample of an analogue image. Forms part of the digitizing process.

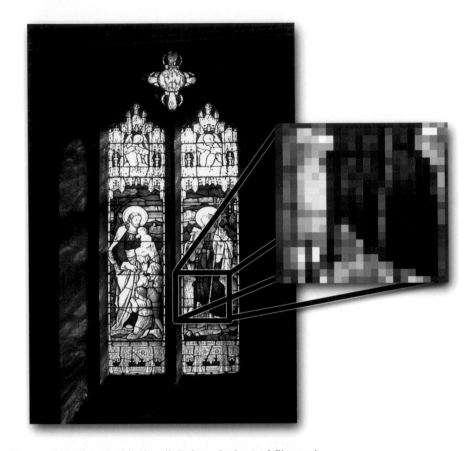

Figure 13.12 The pixel is the digital equivalent of film grain

R

RGB All colors in the image are made up of a mixture of Red, Green and Blue colors. This is the typical mode used for desktop scanners, painting programs and digital cameras. See Figure 13.13.

S

Sponge tool Used for saturating or desaturating part of an image that is exaggerating or lessening the color component as opposed to the lightness or darkness.

Status bar Attached to the base of the window (Mac) or beneath the window (PC). Can be altered to display a series of items from Scratch Disc usage and file size to the time it took to carry out the last action or the name of the current tool.

RGB

Figure 13.13 Digital photographs are typically made up of three components – one for the red parts of the image, one for the green and one for the blue

Stock A printing term referring to the type of paper or card that the image or text is to be printed on.

Swatches In Elements, refers to a palette that can display and store specific individual colors for immediate or repeated use.

T

Thumbnail A low resolution preview version of larger image files used to check before opening the full version. See Figure 13.14.

TIFF or Tagged Image File Format Is a file format that is widely used by imaging professionals. The format can be used across both Macintosh and PC platforms and has a lossless compression system built in. See Figure 13.15.

Figure 13.14 Browsing software often makes use of thumbnails to quickly preview the contents of the full file

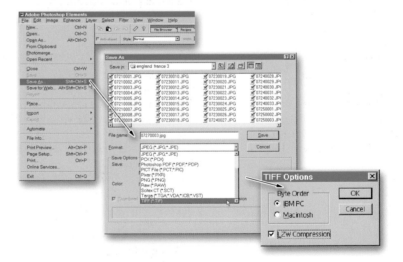

Figure 13.15 The TIFF format uses lossless compression and can be read by both Macintosh and Windows machines

W

Warp tool A means of creating differing distortions to pieces of text such as arcs and flag ripples.

Index

Focal Press

www.focalpress.com

Join Focal Press on-line

As a member you will enjoy the following benefits:

- an email bulletin with **information on new books**
- a regular **Focal Press Newsletter**:
 - featuring a selection of new titles
 - keeps you informed of **special offers, discounts and freebies**
 - alerts you to **Focal Press news and events** such as author signings and seminars
- complete access to **free content** and reference material on the focalpress site, such as the focalXtra articles and commentary from our authors
- a **Sneak Preview** of selected titles (sample chapters) *before* they publish
- a chance to have your say on our **discussion boards** and **review books** for other Focal readers

Focal Club Members are invited to give us feedback on our products and services.
Email: worldmarketing@focalpress.com – we want to hear your views!

Membership is **FREE**. To join, visit our website and register. If you require any further information regarding the on-line club please contact:

> Emma Hales, Marketing Manager
> Email: emma.hales@repp.co.uk
> Tel: +44 (0) 1865 314556
> Fax: +44 (0)1865 314572
> Address: Focal Press, Linacre House,
> Jordan Hill, Oxford, UK, OX2 8DP

Catalogue

For information on all Focal Press titles, our full catalogue is available online at www.focalpress.com and all titles can be purchased here via secure online ordering, or contact us for a free printed version:

USA
Email: christine.degon@bhusa.com
Tel: +1 781 904 2607

Europe and rest of world
Email: jo.coleman@repp.co.uk
Tel: +44 (0)1865 314220

Potential authors

If you have an idea for a book, please get in touch:

USA
editors@focalpress.com

Europe and rest of world
focal.press@repp.co.uk